IMAGES of America
SOUTH PLAINFIELD IN THE 20TH CENTURY

On the Cover: In this photograph taken on Spring Lake around 1957, Frank Curtis of the Lions Club drives his gas-powered machine, with Michael Savard waving to the kids. Passengers made a small donation to the Lions to ride on the contraption. (South Plainfield Historical Society.)

IMAGES of America
SOUTH PLAINFIELD IN THE 20TH CENTURY

Richard Veit and Dorothy Miele

Copyright © 2017 by Richard Veit and Dorothy Miele
ISBN 978-1-4671-2661-8

Published by Arcadia Publishing
Charleston, South Carolina

Printed in the United States of America

Library of Congress Control Number: 2017942083

For all general information, please contact Arcadia Publishing:
Telephone 843-853-2070
Fax 843-853-0044
E-mail sales@arcadiapublishing.com
For customer service and orders:
Toll-Free 1-888-313-2665

Visit us on the Internet at www.arcadiapublishing.com

This volume is dedicated to our families for their help and support, especially Terri, Douglas, Rebecca, and Maryann Veit and Sarah Miele.

Contents

Acknowledgments 6

Introduction 7

1. The Old Home Town 9
2. Local Businesses 21
3. Churches and Cemeteries 35
4. Planes, Trains, and Automobiles 49
5. Families and Neighborhoods 63
6. Education 83
7. In Service 93
8. Community Activities 107
9. Sports and Recreation 115

Bibliography 127

ACKNOWLEDGMENTS

We would like to recognize the many people, residents of South Plainfield past and present, who generously shared their images and archival materials with the South Plainfield Historical Society over the past 42 years. Their interest in family and local history has made this volume possible. A special thanks to the following individuals who donated photographs to the South Plainfield Historical Society: Charles Adams, Mary DeCanto Agrista, the Austin family, William Ball, Hank Bauer, C. Andrew Beagle, Robert Bengivenga Sr., John Brinckmann, Christina Robustelli Bumback, John Burnham, Tulio Capparelli, Dick Gaine, Guido Coladonato, Loretta DeFillipo Conroy, Roseanne DeAndrea Cucurello, Toni Orrico Cvetko, Peter Dalto, Marge DeAndrea, Philomena DeFillipo, Elma Randolph Diana, Wayne Diana, Paula DeFellipo George, Nancy DeFillipo Guarraci, Rich and Betty Lou Hamilton, Marilyn Hayles, Nathan Kadish, Alma Kenney, Jason Koralja, Philip Lippitt, Donald Lokuta, Jean Pyatt Loupassakis, Viola Risoli-Mann, David Mashas, Mary Mazepa, Edward McCarthy, Ed Meehan, Charles Melillo Jr., Helen Carone Meyer, Dorothy Miele, Ann Mieszkalski Bozek, Charles Molineaux, Harold Morse, Marybeth Flaherty-Nagy, Ed Niemczyk, Ruthann Schionning Nuzzo, Vinnie Pellegrino, the Phillips family, Michael Prehodka, Audrea Ranger, Marlene Riccardi, John E. Riley, John Setteducati, Marge Staats Sheldon, John Sideck, Carmen Helmer Smith, Richard Trexler, William Tuthill, Richard Veit, Josephine Mastropietro Wilder, Ellis Williams, Ellie Wilson, Ed Wojciechowski, and John Zazzara.

Photographs by newspaper photographers Dick Gaine, Harold Morse, and R.K. Pederson were also used.

We also appreciate the assistance of Tom Stillman of Stillman Photography Services, Donald Lokuta of Kean University, the Dana Corporation, Harris Steel, Ed Raser, and the Metuchen-Edison Historical Society, which lent photographs from the J. Lloyd Grimstead collection of photographs. A special thanks to John Biggs of Wesley United Methodist Church and Anita Anderson, Nettie Sherby, Rev. Raymond E. Sundland, and pastor Rev. Vasyl Pasakas of the Blessed Virgin Mary Orthodox Church. We particularly appreciate the edits of Larry Randolph and Maryann Veit. Our editor Stacia Bannerman provided critical support and encouragement.

Unless otherwise noted, all photographs appear courtesy of the South Plainfield Historical Society.

INTRODUCTION

South Plainfield, New Jersey, is located in northern Middlesex County and has long been a crossroads of commerce and industry. This volume focuses on the borough's 20th-century history, a time when the region was transformed from an area of farms and rural hamlets to an industrialized and suburban community. Today, the 8.3-square-mile borough of South Plainfield is home to over 23,000 residents. It is a diverse community, proud of its strong community organizations.

The borough is situated in a shallow basin bounded on the east by the terminal moraine of the Wisconsin Glacier, now indicated by a low ridge of hills running along Woodland Avenue. Native Americans, the Lenape and their precursors, found the area to be rich in natural resources, and the archaeological remains of their encampments have been found along many of the borough's watercourses. Colonial settlement began in the late 17th century, when Quakers began to carve farmsteads out of the wilderness. Mills were soon established, including a sawmill and a gristmill. The gristmill, owned at times by the Laing, Randolph, Dunn, and Baker families, was lost to fire in 1909. It stood just southwest of the South Plainfield Rescue Squad and Memorial Park and was powered by water from today's Spring Lake, which was much larger at the time. The sawmill was located on the Bound Brook near the site of the Lakeview Avenue overpass. Many of the early settlers were Quakers, and the Plainfield area is believed to have taken its name from John Barclay's plantation, the Plainfields. Other early settlers were Baptists. During the American Revolution, several skirmishes were fought in South Plainfield. The Drake House on Sampton Avenue was briefly occupied by Col. Israel Shreve during the Revolution. Later, Rochambeau's army marched through town on its way to Yorktown, Virginia, and victory over the British.

By the mid-19th century, life in what would become South Plainfield was concentrated in two crossroads towns: Samptown, the area around the Drake House on Sampton Avenue, and Brooklyn, or New Brooklyn, close to Spring Lake. During the Civil War, South Plainfield residents served in large numbers, especially in the 28th Regiment and the 11th Regiment of the First Brigade of New Jersey Volunteers. By the 1870s, the local post office, housed in Manning's Store on Front Street, was using the name South Plainfield. The loss of the Baptist church to fire in 1879 led the congregation to relocate from Samptown to New Brooklyn. South Plainfield was starting to take shape.

Railroads helped transform the community. The first railroad line, the Easton and Amboy, later purchased by the Lehigh Valley Railroad (LVRR), was constructed between 1872 and 1875. Later, the Rahway and Roselle Railroad connected the Lehigh Valley to the Central Railroad of New Jersey. In the 1890s, the LVRR constructed what was then considered to be the largest coal yard in the world. Enormous pyramids of coal were stored in an area off Metuchen Road, where it could be kept in readiness for shipment to New York City and elsewhere. Large mechanized loaders moved the coal in and out of railroad cars.

In 1906, Milton Mendel purchased the home of Col. John I. Holly on West Crescent Parkway. The neighborhood around his house would come to be known as Avon, Avon Park, and Holly Park. Mendel created a popular resort, with a lake for swimming, boating, and ice skating, and a picnic ground. The lake was also used to harvest ice; in one year, 500 tons of ice were taken from it. Mendel also removed the Lang burial ground, probably the oldest burial place in South Plainfield, claiming that children were changing behind the gravestones and getting injured. At the turn of the 20th century, the Midland Water Company established a pumping station and water filtration plant in South Plainfield. Later, the water company's wells led to a reduction in the pond's water level.

Other neighborhoods developed in the early 20th century. The Spicer Manufacturing Company, established in 1904 by Clarence Spicer in Plainfield at the Potter Press, relocated to South Plainfield and opened a plant manufacturing ball joints and drive shafts on Hamilton Boulevard. Spicer employed hundreds of workers and was known as a caring employer, running picnics, presenting vaudeville shows, and providing a cafeteria for workers. The Scalera Bus Company of South Plainfield helped workers commute to the new Spicer plant. New housing was built in the vicinity of Lakeview Avenue for Spicer's workers called Castle Gardens, perhaps a reference to New York City's Castle Gardens, a precursor to Ellis Island. One other neighborhood that bears note was New Petrograd. Founded by Russian immigrants, it was located between today's Hamilton Boulevard and Park Avenue and was supposedly named by a Russian prince.

Industry found South Plainfield to be a welcoming location in the 20th century, and the massive coal yard was followed by Harris Structural Steel, a fabricator of steel beams founded by George Harris, which opened its main facility in South Plainfield in 1915. It had 10 open yards, one of which was a quarter-mile long. In its lengthy history, the company fabricated the steel for the Betsy Ross Bridge, Throgs Neck Bridge, Verrazano Narrows Bridge, New York's World Trade Center, and more recently, the Liberty Tower in New York City.

In 1924, the US Post Office leased Benjamin Hadley's farm on the southern side of town as the eastern terminus for airmail flights. The first transcontinental night airmail flight took off from Hadley Field on July 1, 1925. The airport remained active until 1968. Today, the site is the location of Middlesex Mall.

The borough of South Plainfield formally incorporated in 1926. Previously, it had been part of Piscataway Township. Two years later, the Spicer Manufacturing Company closed its South Plainfield operation due to a tax dispute and relocated to Ohio, closer to its suppliers and markets. In the 1930s, the Spicer factory was acquired by the Cornell Dubilier Corporation, a manufacturer of electronic equipment, especially capacitors. Other local industries included American Rock Wool, ASARCO, David Smith Steel Company, Kentile Floors, and the Middlesex Dress Company.

The community's population grew and new churches were established, including Sacred Heart Church (in 1905), Our Lady of Czestochowa, St. Mary's, Wesley Methodist Church, and many others. The borough inherited several schools from Piscataway but also began erecting its own schools, starting with Roosevelt School, dedicated in 1929. The South Plainfield Middle School was constructed as a junior high school in 1949 and expanded to serve as a high school in 1955. In 1973, a new state-of-the-art high school was constructed with open classrooms and air conditioning. A series of elementary schools had been constructed in the late 1950s and 1960s, including Franklin School, Cedarcroft School (now Grant School), Kennedy School, and John. E. Riley. The latter was named after a popular principal.

After World War II, South Plainfield boomed. New neighborhoods were developed, starting with Geary Park on Park Avenue. The Cold War saw the construction of a Nike missile base close to the location of Hadley Mall. The command center was on Durham Avenue and the launching site was on Stelton Road. It was closed down in 1971.

As the town's population grew, new facilities were constructed. The South Plainfield Rescue Squad was incorporated in 1944. The Borough Hall was built in 1961. The fire department got a new firehouse in 1967, and a new rescue squad was also constructed. In March 1965, a new public library was built. Route 287, constructed in the 1960s, divided the borough but led to more development on the south side of the community. A considerably expanded and revamped public library opened in March 2016.

Today, South Plainfield is a largely residential community in northern Middlesex County. Proud of its rich heritage and community organizations, it looks to the future.

One
THE OLD HOME TOWN

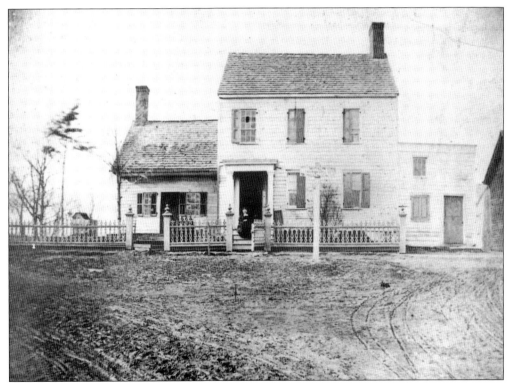

The most iconic structure still standing in South Plainfield is the Drake House at 746 Sampton Avenue. Built in 1762 by Joseph and Catherine Drake on a main road from Elizabeth to New Brunswick, it was at various times a private residence, tavern, store, and rest stop for the colonial Swift Sure Stage Line. The smaller portion of the house (at left) may be the original structure.

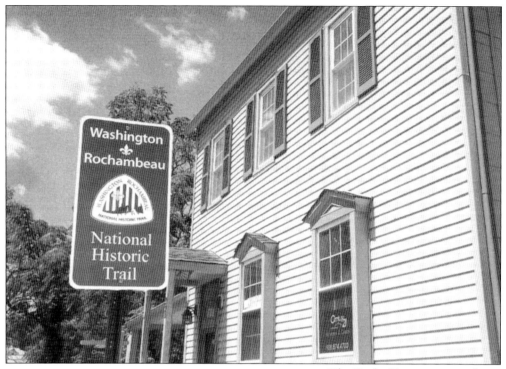

The Drake House is situated on the Washington-Rochambeau National Historic Trail that runs through central New Jersey. American troops passed by on their way to the Battle of Yorktown in 1781. During the Revolution, Col. Israel Shreve of the 2nd New Jersey Regiment briefly used the house to hold a court martial. Recently, historical markers were erected at several locations in town to show where the troops passed.

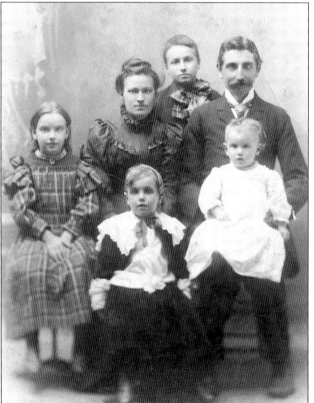

Mary and Samuel Pyatt Jr. and four of their seven children, from left to right, May, Russell, Lena and Monroe (in back) once lived in the Drake house. Samuel, who was born in Samptown, was a carpenter by trade. While taking a shortcut across the Lehigh Valley Railroad tracks near his home to go to work, he was struck and killed by a fast freight train in 1916.

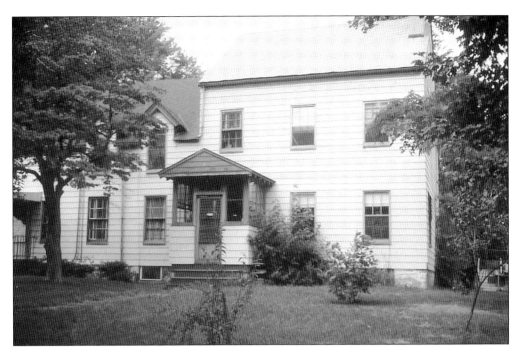

This historic dwelling at 179 Sprague Avenue was formerly known as the Country Lounge. The popular restaurant/bar/nightclub was owned by 1930s amateur boxing champion Tony Orrico, later the manager of pro boxer and New Jersey Boxing Hall of Famer Jimmy Walker. Today, it is again a private residence and serves as a multifamily home.

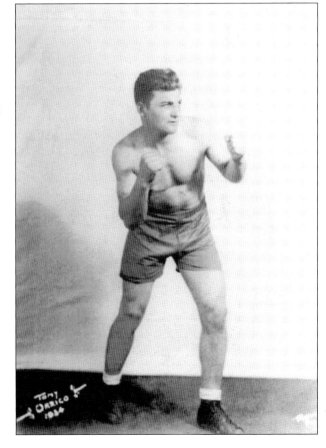

Boxing champion Tony "Kid Dynamite" Orrico is pictured here in 1934. Born in Mississippi, he moved to South Plainfield when he was just four years old. He boxed in the welterweight division and had two knockouts. After his boxing career ended, he owned the Country Lounge for 33 years and was also a noted pigeon fancier.

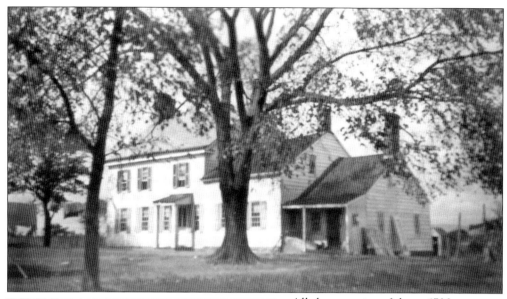

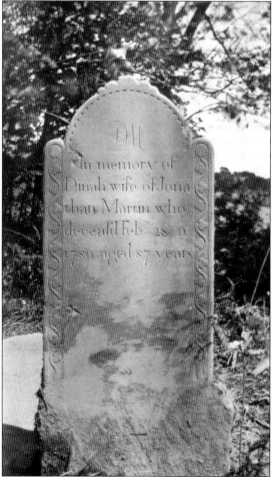

All that remains of the c. 1700s Martin-Page farmhouse is this J. Lloyd Grimstead photograph from 1933 and three images of headstones in the Martin family plot on the property. The last owners, George and Marie Page, vacated the farm near the intersection of Hadley Road and Durham Avenue in the 1960s for the construction of Interstate 287.

The Dinah Martin gravestone, dated 1780, once stood in the Martin family cemetery. Carved from sandstone, it was a fine example of a late 18th century grave marker. It was likely carved by Jonathan Hand Osborne of Scotch Plains. There were once several family burial grounds in South Plainfield; however, they have all been lost.

The John Geary House at 2100 Plainfield Avenue was originally built by the Randolph family in 1840. The Mannings purchased the property in 1859. In 1913, Geary, who was living on Oak Tree Road, tired of the noise from Spicer Manufacturing Company's drop forge and bought Manning's farm. In the early 1950s, the farm became the Geary Park development. In 2001, the old house came down, and six new ones arose on the site.

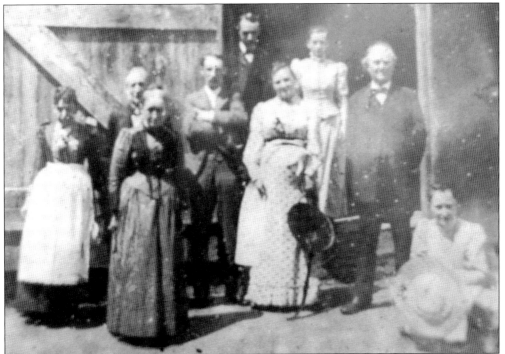

Joel Manning and his family are pictured here around 1870. They are standing in front of the barns on their farm, which stood on Plainfield Avenue, across from today's middle school. Joel Manning gave up farming in 1907 and moved to Plainfield. By 1909, most of the old farmers who had lived on today's Plainfield Avenue had left the area.

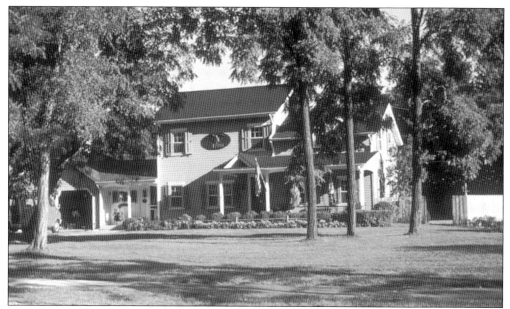

This is the c. 1795 Blackford House, now at 1579 Bullard Place, which originally stood on Plainfield Avenue on the site of the Wesley United Methodist Church parsonage. It may have originally been an outbuilding or tenant farmer's residence, part of a bigger Blackford estate located closer to the Plainfield border and now lost to history.

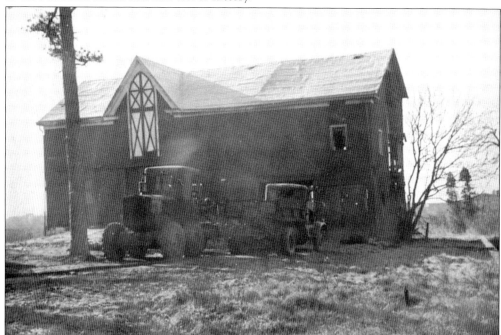

This barn was located behind Justice of the Peace William E. Smith's farmhouse on Plainfield Avenue, the site of today's municipal complex. The Borough of South Plainfield bought the house and barn in 1943 with the intention of housing municipal offices in it, but lack of funding prohibited renovations. Instead, the farmhouse was leased to the American Legion, and the barn in the rear was used for the municipal works department.

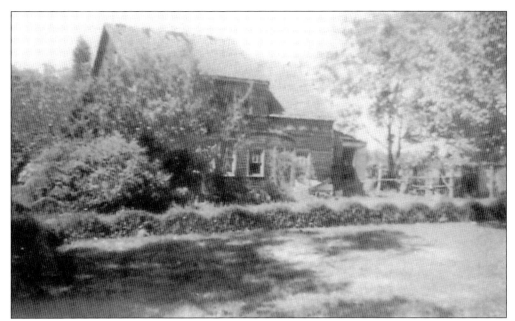

This colonial farmhouse on Delancy Court was owned by the Adams family since 1905. It stood on the edge of the Lehigh Valley Coal Storage Facility and the Dismal Swamp. The house was demolished in the 1920s for a new residence. The second house was demolished by Middlesex County when it purchased the property for open space a few years ago.

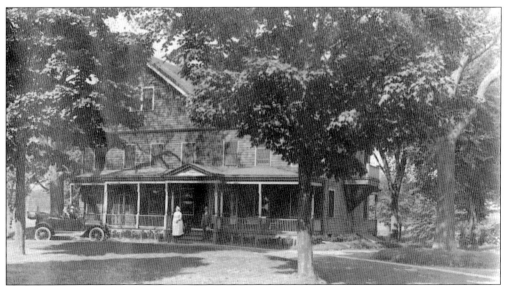

Milton Mendel arrives at Holly House with his mother as the housekeeper waits on the steps. Mendel bought Col. John I. Holly's 100-acre estate on West Crescent Parkway in 1906. He intended to convert the three-story c. 1800 house into a rest home for weary city dwellers, but problems getting domestic help thwarted his plans. He created Elk Realty and subdivided the property, establishing Holly Park, a housing development.

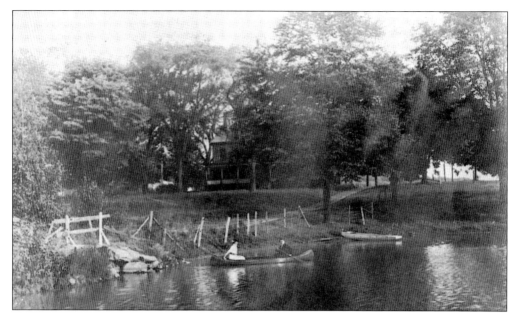

Milton Mendel and cousin Selma canoe on Holly Pond around 1907. Mendel expanded the six-acre pond to nine acres. Sand was spread on the pond's bottom and banks, and the site opened as a bathing beach. In 1922, Mendel sold the house to N.A. Helmer Sr. The pond section of the property became an amusement park, which was a popular venue for beauty pageants, swim meets, and corporate picnics.

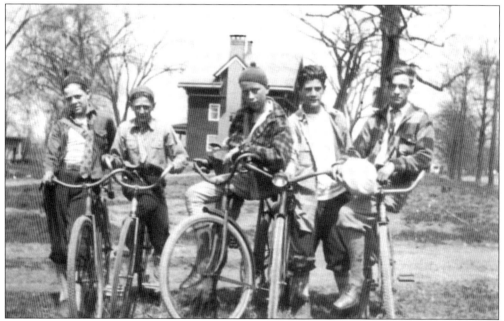

These young fellows called themselves "the Knights of the Coaster Brake." They are, from left to right, Robert Wimmer, Gordon Britland, Frank Helmer, William Setteducoti, and Robert Smith. The 18-room Holly House stands in the background of this c. 1927 image. Frank Helmer became an admiral in the Coast Guard during World War II, and Robert Smith married Frank's sister Carmen, who provided many of the photographs in this book.

The William and Ellen Ball house on Metuchen Road was an attractive dwelling with pleasant shade trees. It was demolished in March 2003 when MarinoWare, a company that makes metal framing, expanded its operations. Today, the site is covered by a road, an outdoor storage area, and a storm water retention basin.

This Queen Anne–style carriage house at 1624 Plainfield Avenue was associated with the Endress-Hall family, whose home reputedly served as a speakeasy during the 1920s. The former property owner offered it to the South Plainfield Historical Society for a museum if the nonprofit could move the building off the property.

The house known as Cedarcroft was situated on 16 acres that extended from Rahway Avenue to North Madison Drive. It was owned by C. Tittsworth in the 1920s. Beginning in 1951, subdivisions whittled down the property until the estate house itself was demolished in 1968. Dave Mashas prepared this architectural drawing.

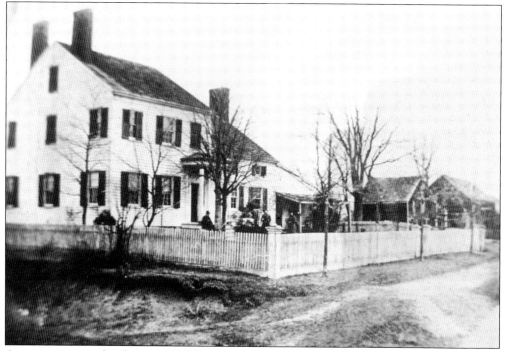

At various times, this farm at 1409 Clinton Avenue was owned by the Manning, Martin, and Stockoff families. The Stockoffs bought the property around 1929 and named it Hillcrest Farms because of its hilltop location. The farm became a popular destination for locals to purchase flowers, vegetable plants, and fresh produce through the 1960s. The house burned in a tragic fire in 2012 that took the lives of several residents.

This is a view of the wide-open fields of the Manning-Martin-Stockoff farm around 1900, looking to the east.

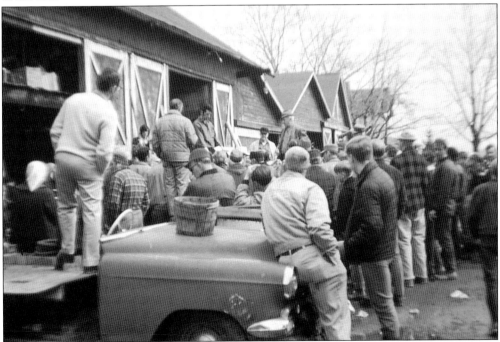

This 1971 photograph shows the farm auction during the final days of the Stockoff farm, when Hillcrest farm closed down. Through the 1960s, the family ran a popular farm stand. Soon, the farmland would be planted with its final crop, new houses, as South Plainfield became increasingly suburban.

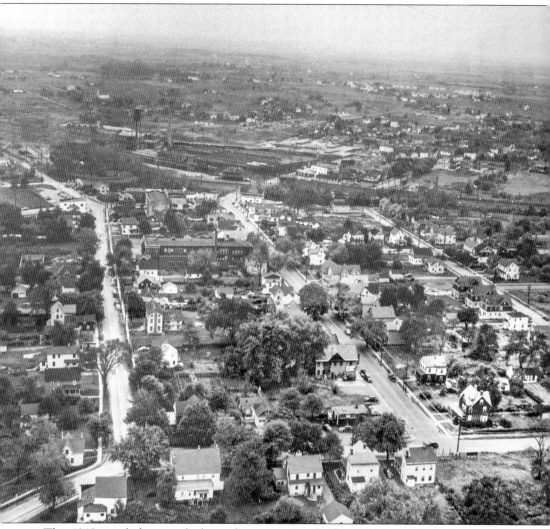

This 1948 aerial photograph shows downtown South Plainfield from Maple Avenue. The top of the photograph is to the south, and Cornell Dubilier, the Lehigh Valley Railroad, and the South Plainfield station can be seen. Front Street is to the left, and Hamilton Boulevard is at center. The old Grant School is the large building in the center of town. Several buildings that have now been lost are visible, including the Ledden House, a tall, narrow, two-and-a-half story Federal house from the 1830s facing Front Street. Haris Foreign Cars still stands on the corner of Maple Avenue and Hamilton Boulevard; it was formerly Bori's garage. The south side of town is largely undeveloped. The dead-end street on the right, now Lakeview Avenue, replaced Hamilton Boulevard as the main thoroughfare through town when the LVRR built an overpass in 1971.

Two

LOCAL BUSINESSES

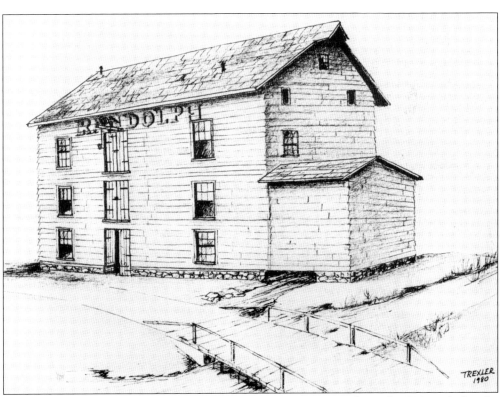

The gristmill built by William Laing had been in operation since the early 1700s and played a significant part in the economic and cultural life of the community. The mill was a community center for religious, social, political, and cultural events and played a role in the community lifestyle. The mill (also known as Randolph Mills and Brooklyn Mills) was a landmark and identifying symbol of the community, being both the largest and most frequently visited building in the vicinity. After a fire destroyed it in January 1909, the community continued its industrial growth as the basis for today's development. This is a 1980 drawing of the mill by Richard Trexler.

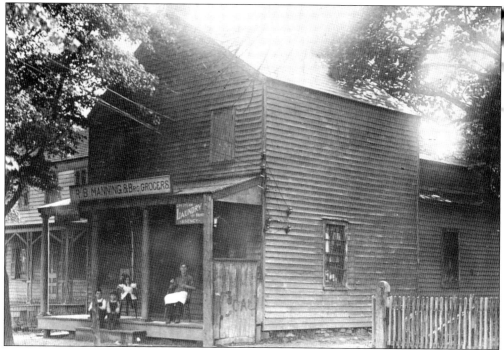

Reune and William Manning operated one of New Brooklyn's earliest businesses at 130 Front Street. Constructed in 1869, it boasts several firsts in local lore: the first general store, first post office (1877), and first telephone installation. This photograph, taken around 1910, was donated by Elma Randolph Diana, who sits on the porch. The building still stands.

Catherine Phillips rented this building at 240 Lehigh Avenue (now Hamilton Boulevard) at the head of South Plainfield Avenue from businessman William Norman, who owned the hotel and bar down the street. There, she operated a wildly popular ice cream, confectionary, and tobacco store on the first floor and lived with her husband and four sons on the second. A big scoop of ice cream cost a nickel. This image was captured around 1914.

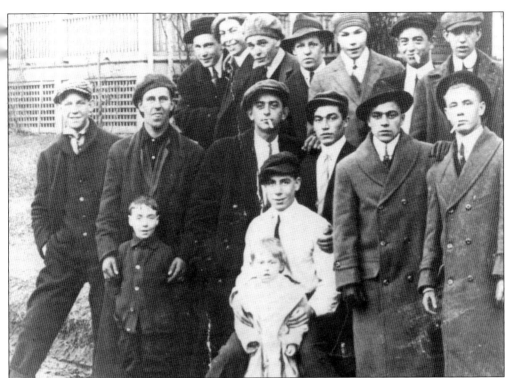

These well-dressed young men are some of the customers who frequented Catherine Phillips's store around 1914. They are, from left to right, (first row) Nip Sofield, John McDonough, and an unidentified child; (second row) Harry Randolph, Dan Sofield, E. Colfax, Frank DeFillipo, Joe DeFillipo, and James Thornton Jr.; (third row) Cliff Brown, Joe Harlow, Bill Teeple, unidentified, John Hogan Sr., D. Colfax, and unidentified.

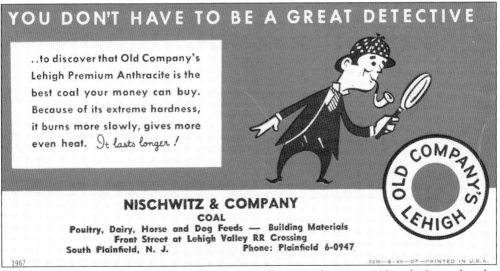

Nischwitz and Company was founded locally by William Nischwitz in 1895 and relocated to the Lehigh Valley Railroad grade crossing at 223 Front Street in the 1920s. It is the second oldest still-active business in South Plainfield after Harris Steel. The company went from selling coal and farm supplies to pet food and oil and remains a thriving business today.

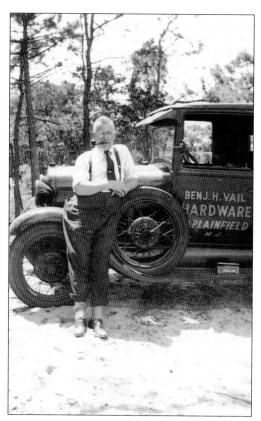

Benjamin H. Vail owned and operated Vail's Hardware at 189 Front Street from around 1925 until 1952. The building, constructed in 1916, was originally the John B. Geary Grocery and Post Office. The store is remembered as having rolling wooden ladders across the perimeter to help customers reach the merchandise. Vail rented ice skates in the winter and, for a while, had gas pumps in front of the store.

Sam Jordan (far right) was the proprietor of Jordan's Meat Market on Hamilton Boulevard, where dressed turkeys and cured hams hung from the wall and sawdust covered the floor. Wife Tootsie, nephew Freddie Lippitt, and the hired help pose for the photographer here around 1930. Freddie's father, Louis, owned the Lehigh Hotel around the corner.

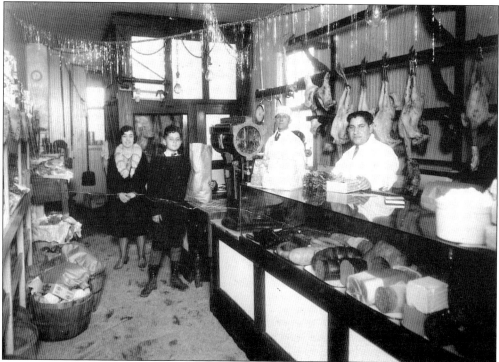

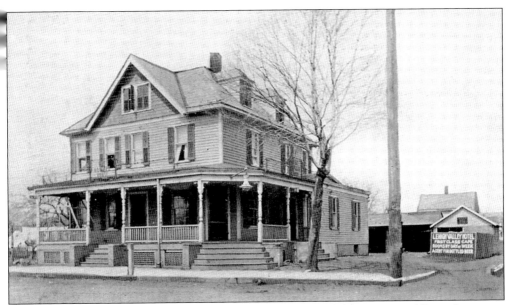

The Norman House hotel and bar at the corner of South Plainfield Avenue and Front Street was sold in 1915 to Louis B. Lippitt, who renamed it the Lehigh Hotel. Note the sign that advertises, "First Class Café, Rooms by Day or Week," and "Agent for Bottled Beer." When Prohibition closed the bar, Lippitt opened the Piscataway Hosiery Mill on the site, which made baseball uniforms.

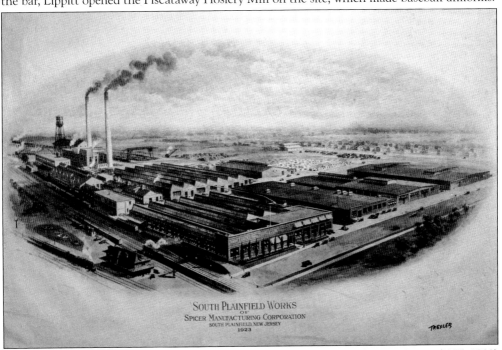

This lithograph shows the Spicer Manufacturing Plant around 1923. Clarence Spicer (1875–1939) was a mechanical genius who made significant improvements to steam-powered automobiles and universal joints in automobiles. He established his first shop in Plainfield in 1904 and relocated to South Plainfield in 1910. In 1916, Charles Dana became president of the firm, which continued to thrive through the 1920s. It relocated to Toledo, Ohio, in 1928.

The importance of Spicer Manufacturing Company to the growth and development of South Plainfield cannot be stressed enough. From 1910, when it relocated its drop forge facility next to the Lehigh Valley Railroad Perth Amboy spur, it became a major employer of local residents

and supporter of local issues, such as the fight to get better transportation services and roads in the community.

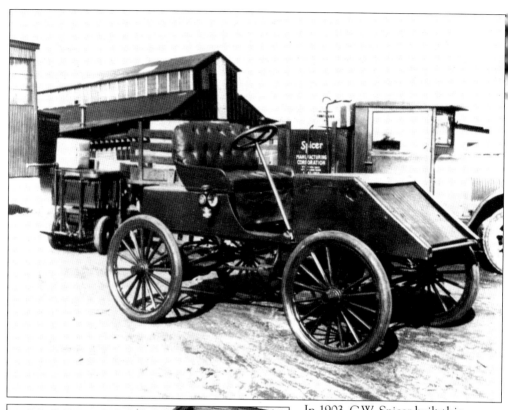

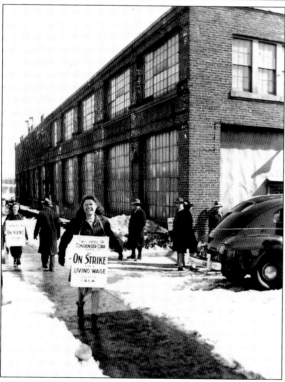

In 1903, C.W. Spicer built this experimental car while still a student at Sibley College, Cornell University. The car helped him develop his idea of a universal joint and shaft to replace the chain drive. This picture was taken at the Spicer plant in South Plainfield. Sadly, the car was scrapped during a World War II scrap metal drive, long after Spicer Corporation relocated to Ohio.

The Condenser Corporation of America (Cornell-Dubilier) moved into the vacated Spicer plant in 1935. It made capacitors, transistors, and other electronic equipment. Mary Burnham, a resident of Castle Gardens on Lakeview Avenue, walks a picket line in the 1940s. Today, contaminated soil at the superfund site has been remediated. Work is still underway on associated contamination of ground and surface water.

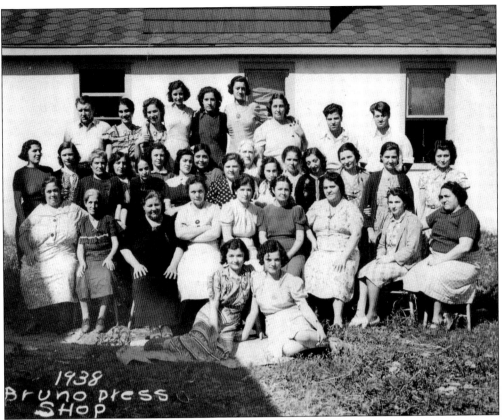

This is a photograph of Bruno Dress Shop on Hillside Avenue in 1938. From left to right are (on the ground) Pia Bruno and Teresa Leonardis; (first row) Jenny Gaudiosi, three unidentified, Concetta Bruno, Bambina Randella, Filomena Tedesco, Elta Bruno, and Rosa Cotone; (second row) two unidentified, Maria Leonardis, four unidentified, Polina Versa, Kay Mastropietro, two unidentified, Olga DeSantis, two unidentified, and Teresa Maleck; (third row) Walter Maleck, two unidentified, Ediuiggia Bruno, Angela Randella, unidentified, Mary DeFillipo, and Joseph and Ralph Bengivenga.

Anthony DeAndrea managed the local A&P store at 30 South Plainfield Avenue in the 1930s. Already a chain of 13,000-plus stores, the local branch closed when the company built a large store in Plainfield. DeAndrea declined an offer to manage the store and opened his own grocery in the same location. Son Joseph took over in 1946 and sold it in 1954 to Michael D'Amico, who renamed it Mickey's Market.

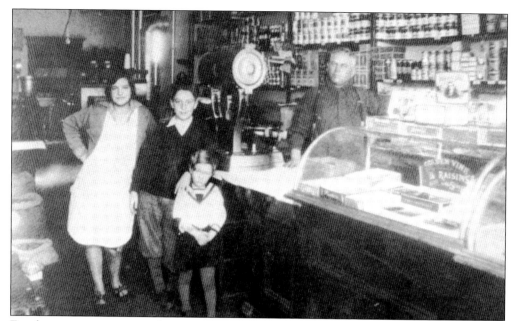

For the most part, mom-and-pop stores are a thing of the past. But from the 1920s through the 1940s, South Plainfield was rich in family-owned-and-operated businesses known for their friendly service. Pietro and Flora Dalto ran such an establishment on Hamilton Boulevard near New Market Avenue. They specialized in Italian foods and were in business from 1921 to 1957. Pictured around 1929 are, from left to right, employee Theresa (Butrico) DiSesso, Dalto's sons Livio and Peter, and Pietro Dalto.

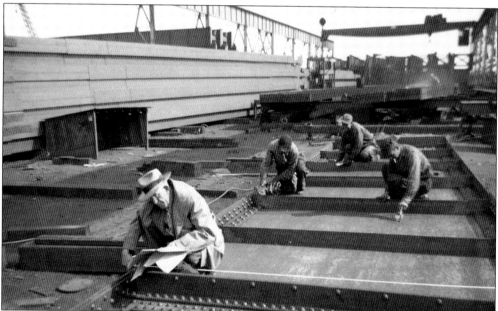

Harris-Silver-Baker Company of Brooklyn, manufacturers of structural iron and steel, purchased the David Blackford farm in 1915 and began erecting a sprawling plant at 1640 New Market Avenue that spring. Harris Steel gave employment to between 400 and 500 men when it opened. It is South Plainfield's oldest operating business. Here, workmen assemble a truss around 1950.

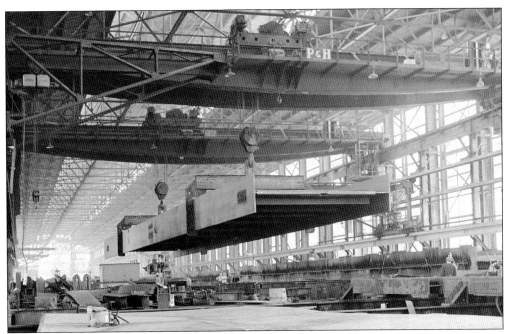

This c. 1950 photograph shows the cavernous spaces inside Harris Steel. A few of the noteworthy structures that include Harris steel are the original World Trade Center and the new One World Trade Center, the Brooklyn tower of the Verrazano-Narrows Bridge, the Daily News Building, and the Port Authority Bus Terminal. During World War II, Harris produced landing craft.

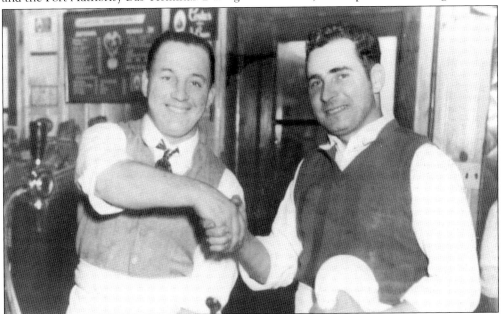

Ed and Charles Wociechowski shake hands upon opening the Knotty Pine Diner on Park Avenue in 1952. The brothers constructed it themselves on weekends on a strip of property noted for bars that remained open an hour longer than those in neighboring Plainfield. They thought a restaurant would thrive in the area. Ed, a former truck driver, became the cook. In the 1960s, the restaurant was expanded and rebuilt.

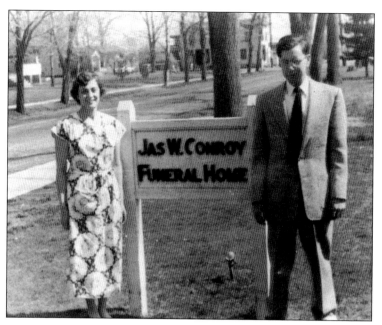

Loretta and James Conroy are pictured in front of the first funeral home in South Plainfield, established in 1949 on Plainfield Avenue. James, a former seabee in World War II, had purchased the Victorian house, built additions, and went into the funeral parlor business. Loretta and James met—where else—at her grandmother's wake at Conroy's funeral home.

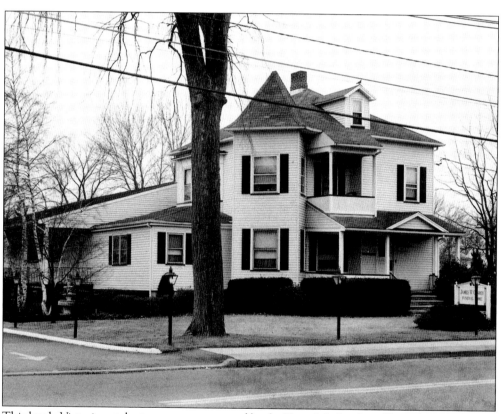

This lovely Victorian-style structure, once owned by the Truesdale family, still stands to the west of the South Plainfield Municipal Complex. It was the James W. Conroy Funeral Home, and is now the South Plainfield Funeral Home, owned by McCriskin-Gustafson Home for Funerals LLC.

Bandy's Ice Cream parlor, on the corner of Maple and Park Avenues, was a favorite spot for cool and refreshing treats. Famous for its soft-serve ice cream, the parlor later added a restaurant wing. Many lamented Bandy's passing in favor of a drugstore. Today, the site is a Rite Aid.

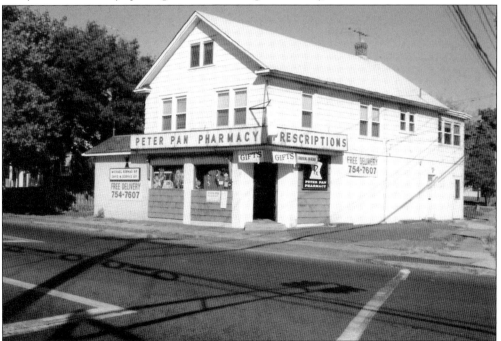

Gil Klein's Peter Pan Pharmacy was originally located in downtown South Plainfield. Klein relocated to the corner of Park and Maple Avenues in 1959, where Gus's Market once was. Later, he sold the business to Michael Kornas and Herbert Leonard. The pharmacy is now operated by the Kornas family.

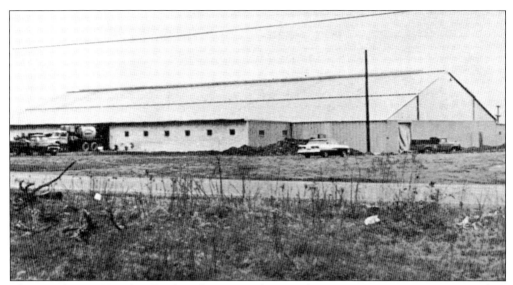

The Ice Palace on Hamilton Boulevard announced its grand opening on January 3, 1961. According to an advertisement in *Suburban Living*, the ice floor was 200 by 85 feet and resurfaced after each session; the modern, all-steel, insulated and dehumidified building was temperature controlled at 50 degrees. Today, the building is the All Seasons Sports Academy.

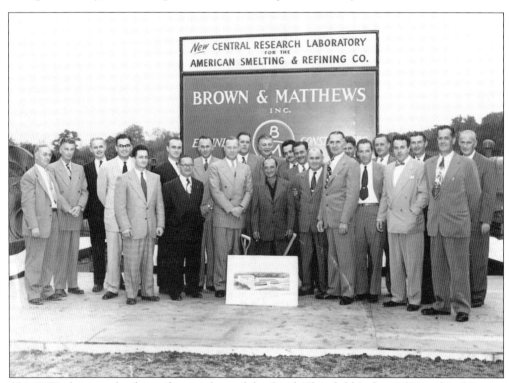

This 1952 photographs shows the members of the South Plainfield Industrial Board and Brown and Matthews Architects. The project is the American Smelting and Refining Company building at the intersection of Park Avenue and Oak Tree Road. The building constructed on this site was demolished in the late 1990s to make way for Oak Park Commons.

Three
CHURCHES AND CEMETERIES

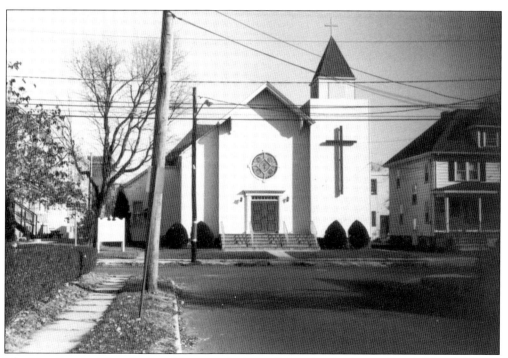

The First Baptist Church, the oldest continuing religious institution in South Plainfield, was founded by local Baptists in 1792 as the Samptown Baptist Church. The first meetinghouse was erected the same year on New Market Avenue. It was expanded in 1814, torn down and replaced by a larger church in 1834, and burned in 1879. The present building at 201 Hamilton Boulevard was dedicated in 1880.

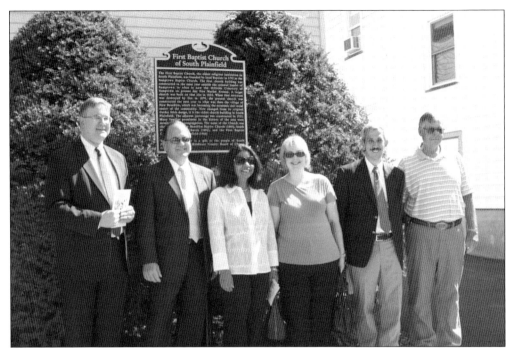

This photograph was taken during the installation of a historical marker, donated by the Middlesex County Board of Chosen Freeholders, at the First Baptist Church on September 19, 2010. From left to right are Rev. Gordon Braun, Mayor Charles Butrico, Isha Vayas and Katie Zavoski of the Middlesex County Cultural and Heritage Commission, Richard Veit, and Larry Randolph.

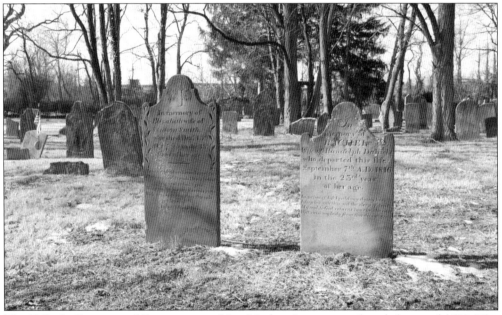

The Hillside Cemetery of Samptown on New Market Avenue was founded around 1690. The oldest legible headstone is that of Benjamin Hull, who died in 1745. Veterans from the American Revolution through the Vietnam War have been buried here. There are a large number of graves from the early 1800s, when the Samptown Baptist Church stood here.

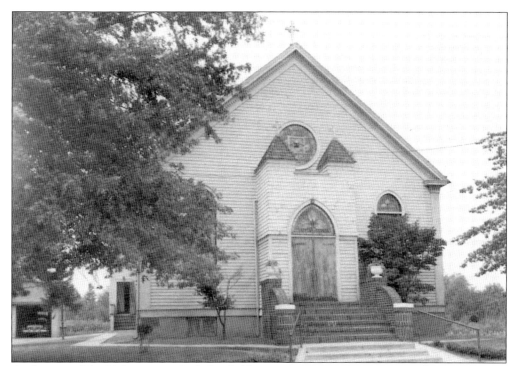

At the turn of the 20th century, Catholics held services in private homes, in Washington Hall on Maple Avenue, or traveled to St. John's Church in Dunellen. The original Sacred Heart Church on South Plainfield Avenue was organized in 1906 under Fr. Edward Dunphy and built in 1907. John Geary and Thomas Savard sold the property to the church, pictured around 1915.

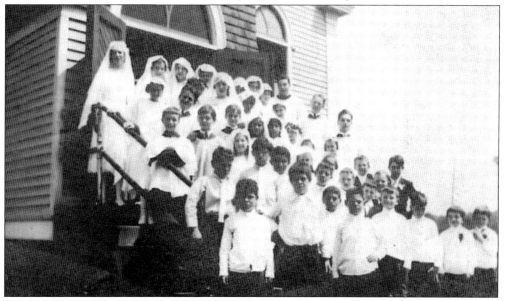

These children are dressed for First Holy Communion on the steps of Sacred Heart Church around 1915. The church was a modest frame building. Many of the parishioners were new immigrants from Italy, Ireland, and Poland. The first parish priest was Fr. John F. Baldwin. During Father Baldwin's tenure, the building was considerably expanded.

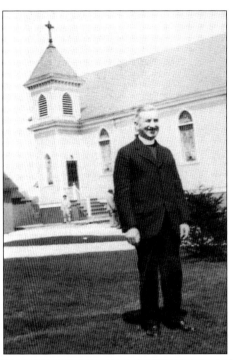

In 1909, Father Baldwin was appointed the first pastor of Sacred Heart Church. Father Baldwin was a popular priest and the congregation grew under his leadership. He also acquired property between Clinton and New Brunswick Avenues for Holy Redeemer Cemetery. Baldwin was succeeded by Fr. Thomas A. Campbell in 1929.

Fr. James Harding presides over a group of children dressed for First Holy Communion in 1944 at Sacred Heart Church. Harding served the church from 1944 to 1951. He had hoped to build a parish school but passed away before he was able to. Rev. Alfred T. Sico succeeded him and was able to bring the plans for a school to fruition in 1953.

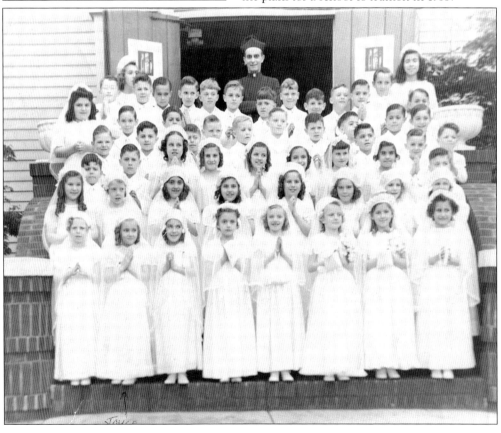

Charles Melillo Jr. stands next to a statue of Jesus on the grounds of Sacred Heart Church around 1937 while serving as the ring bearer at the wedding of Helen Dellavalle. The church and a garage are visible in the background. A school and convent were added to the parish grounds over the years.

The new Sacred Heart Church was built in 1964. A soaring building of Indiana limestone and buff-colored brick, it may have been intended to serve as the seat of the Diocese of Metuchen. Holy Savior Academy, to the right of the church, was previously Sacred Heart School. Its gymnasium was once used for services.

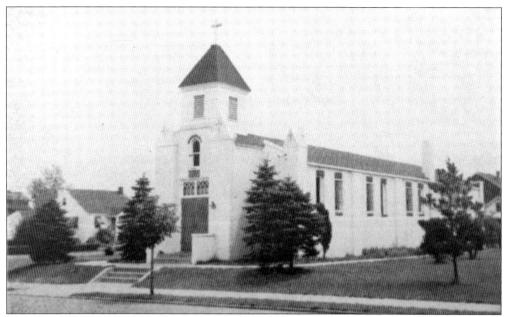

Our Lady of Czestochowa Church, at 909 Hamilton Boulevard, was established in 1943. Its first pastor was Rev. Ladislaus Madura. The congregation first held masses in a building known as Venetian Hall on Hamilton Boulevard. During World War II, the parishioners obtained a mess kitchen from Camp Kilmer, which was repurposed as a sanctuary and served for 33 years.

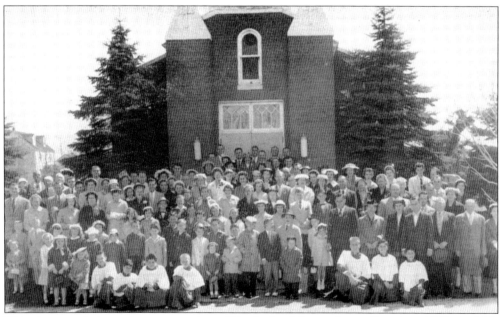

This photograph shows the congregation of Our Lady of Czestochowa Church in 1958, the 25th anniversary of the church. The parish grew rapidly in the 1940s and 1950s. The church had a recreation center and also a convent at 1411 Hamilton Boulevard. The sisters provided religious education for the young people of the community.

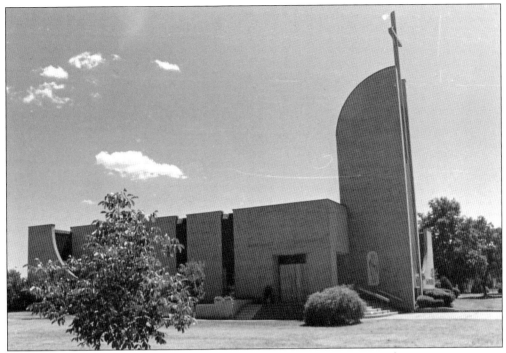

In January 1976, the old church was demolished to make way for a new, modern structure costing roughly $400,000. Today, the church, which was once primarily Polish, has a growing Vietnamese congregation and is now known as Our Lady of Czestochowa and La Vang.

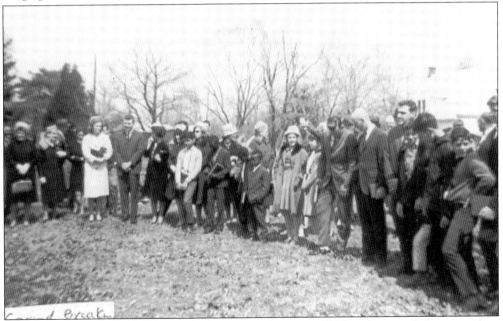

Cedarcroft Bible Chapel is pictured at its ground breaking in 1965. This photograph shows members of the congregation at that event. The chapel had its origins with the Independent Brethren Movement in the 1890s. After moving from location to location in Plainfield and North Plainfield, the congregation acquired property in suburban South Plainfield, where it remains to this day.

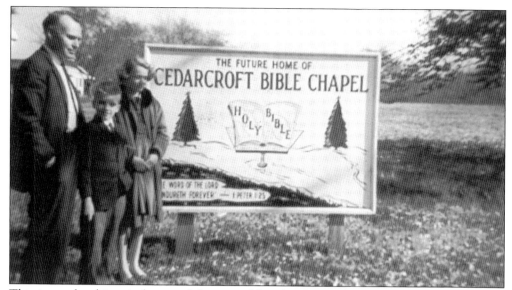

This is another historical view of the ground breaking at Cedarcroft Bible Chapel. A nondenomination Bible-focused evangelical Christian congregation, its members have long been involved in a wide variety of community activities and are always active participants in South Plainfield's Labor Day parade.

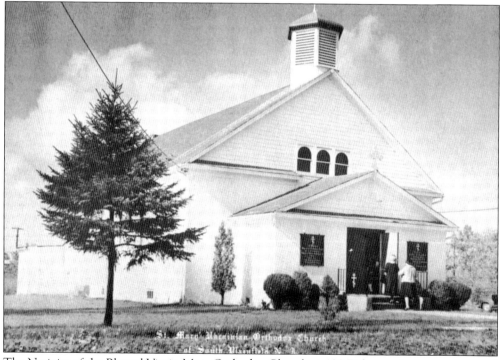

The Nativity of the Blessed Virgin Mary Orthodox Church at 400 Delmore Avenue was erected in 1958 on Delmore Avenue, replacing an earlier structure that originally belonged to the Ukrainian National Association Branch No. 312 until 1935, when it was transferred to St. Mary's Ukrainian Orthodox Church and Society. (Anita Anderson, Nettie Sherby, and Rev. Raymond E. Sundland.)

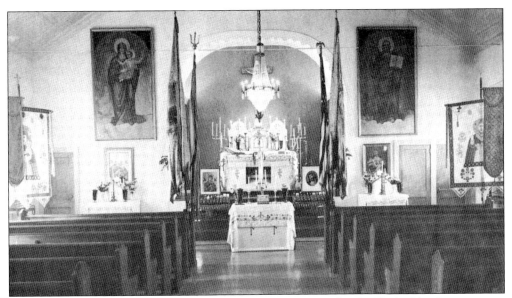

The interior of St. Mary's Ukrainian Church is shown here around 1958. The building's cornerstone was laid on Christmas Day 1934 by Archbishop Athenogoras of Constantinople. The Rev. Vasil Fedyshyn was appointed first pastor in 1935. Today, Rev. Vasyl Pasakas is the pastor. (Anita Anderson, Nettie Sherby, and Rev. Raymond E. Sundland.)

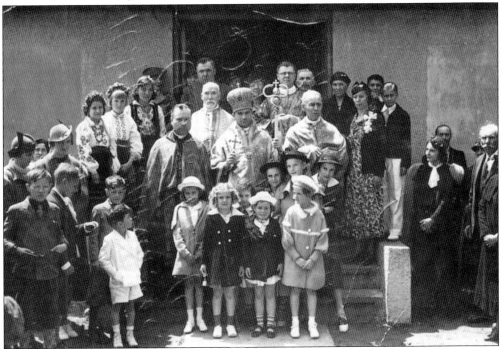

This image was captured during a visit by Metropolitan Bishop Bohdan to the Blessed Mary Orthodox Church. Others pictured include Rev. John Fedyna (pastor), Reverend Symyatsky from New York, Rev. N. Pidhorsky of Philadelphia, Rev. Peter Zurawetsky of New York, and Nettie Sharyk Sherby, Julia Bilcky, and Mary Fessock Dudack in Ukrainian dress. (Anita Anderson, Nettie Sherby, and Rev. Raymond E. Sundland.)

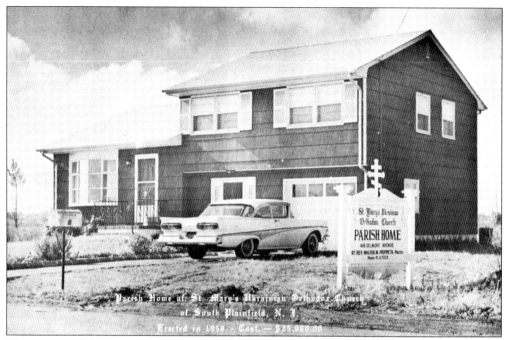

The new parish house at St. Mary's Orthodox Church, pictured here in 1958, was erected at a cost of $25,000. This almost coincided with the silver anniversary of the congregation, which drew its membership from South Plainfield and the surrounding region. (Anita Anderson, Nettie Sherby, and Rev. Raymond E. Sundland.)

The ground breaking for St. Stephen's Evangelical Lutheran Church at 3145 Park Avenue took place on November 22, 1959. Founded in 1955, the congregation previously met in Grant School. Rev. Robert Loucks was the first pastor. A major addition was constructed in 1967, giving the building its current appearance.

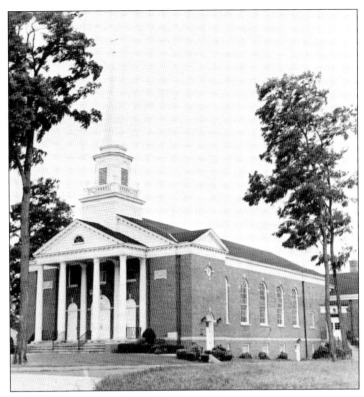

Wesley United Methodist Church at 1500 Plainfield Avenue held its first worship service in 1960. The congregation began in the 1890s and was previously located in Plainfield, known as the Monroe Avenue Methodist Church. The church is a beautiful brick Georgian structure named after the founder of Methodisim, John Wesley. (Wesley United Methodist Church.)

Walter Harris, a major benefactor of Wesley United Methodist Church, helped secure the lot and pay for the construction of the edifice. His father, George Harris, founded Harris Steel, one of South Plainfield's leading industries. Walter began working there as a child. His grandfather was an early supporter of the Salvation Army. (Wesley United Methodist Church.)

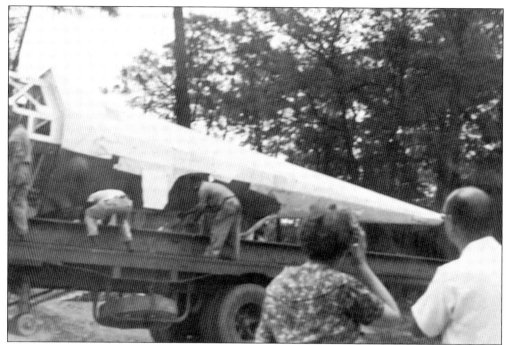

In 1949, the Harris Memorial Trust Fund was established to help pay for building a new church as a memorial to George Harris and his wife. Ground breaking for the new Wesley United Methodist Church began on February 22, 1958. Edward D. Conklin was the first pastor. This photograph shows the steeple arriving by truck. (Wesley United Methodist Church.)

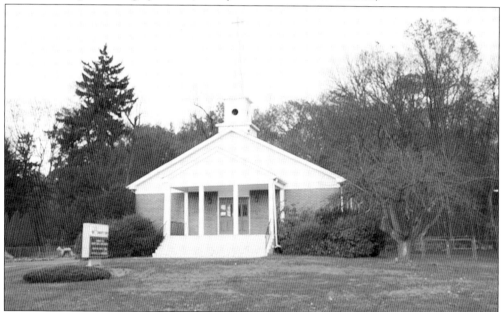

Pilgrim Covenant Church at 3121 Park Avenue was founded in 1901 by Swedish immigrants in Plainfield. It relocated to South Plainfield in the 1960s, and the current structure was completed in 1964 at a cost of $70,000. More recently, it became the Park Community Church, and in 2016, under the leadership of Pastor Robert Nieves, it merged with the New Walk Church.

St. Stephen the Protomartyr Church, on Lake Avenue, began as a shrine built by Senka Wrublevski in 1941 on the sunporch of her home as a way to pray for her five sons' safe return from military service during World War II. Wrublevski was of Ukrainian descent and was born in Austria. She came to South Plainfield in 1927.

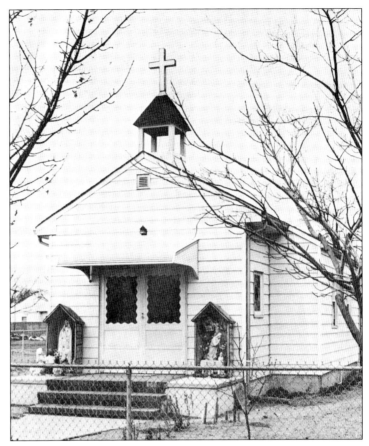

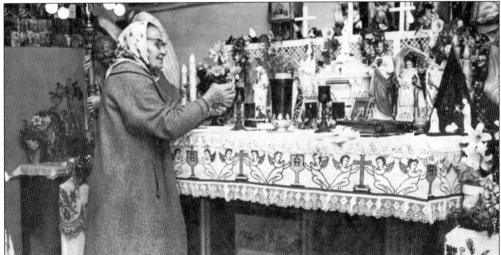

In 1951, the chapel was moved to a garage beside her home and renovated by Senka Wrublevski and members of her family. Her prayers in the chapel reportedly led to several miracles. This photograph shows Wrublevski in the chapel in 1967. In 1978, it was donated to St. Stephen the Protomartyr Antiochian Orthodox Church. The church has grown over the years and is well known for hosting South Plainfield's International Festival.

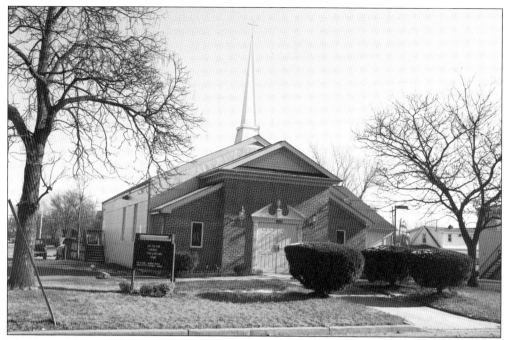

The Rescue House of Prayer at 1921 Roosevelt Avenue is a nondenominational Christian church. It was founded in 1945 by Bishop Hattieque Southgate in a garage next to where it stands today. The House of Prayer was incorporated in 1950 and is presently led by Rev. Dr. Irene M. Campbell.

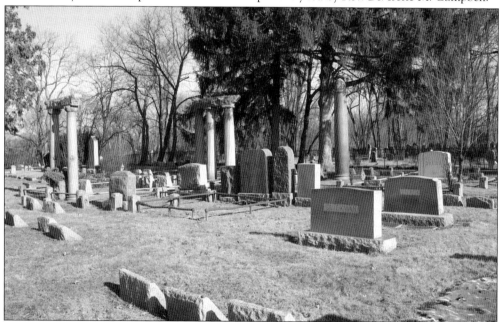

South Plainfield's Jewish cemetery on New Market Avenue is associated with the United Orthodox Synagogue of Plainfield. It was established in 1894 on land that had once belonged to the historic Hillside Cemetery. When it was founded, congregants paid $12 per lot on the southwest corner and $10 per lot on the northwest corner. It has some beautiful artistic memorials, including these columns and monuments from the early 20th century.

Four

Planes, Trains, and Automobiles

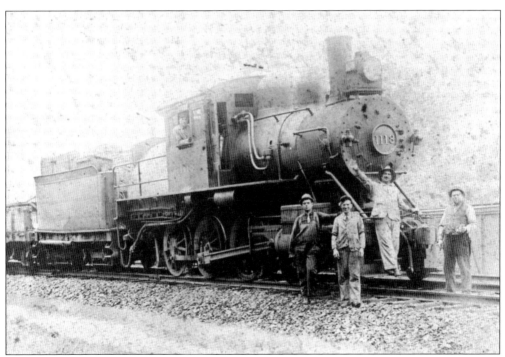

This photograph shows the Lehigh Valley Railroad's Engine 1113, a steam-powered camelback, at South Plainfield. For years, this photograph and a dozen others were stored in a cardboard box in the attic of the Flaherty/McDonough family home on Hamilton Boulevard. The box traveled with family members when they moved, coming to rest at Marybeth and Bill Nagy's residence. The pictures were discovered in 2004, when the box was nearly put out for curbside pickup.

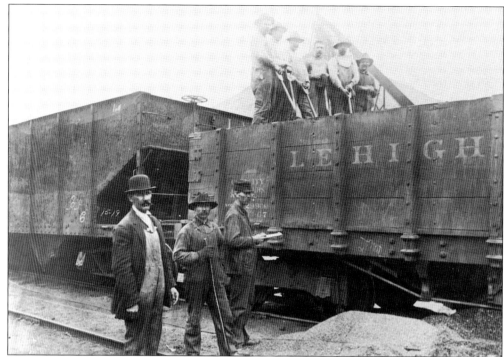

The first LVRR train carrying coal from Pennsylvania passed through South Plainfield on May 28, 1875. The railroad employed many local residents, including these men. From left to right are Anthony Phillips, Michael Bozek, and Stanley Leach; George Niemczyk is on top of the coal car at far right.

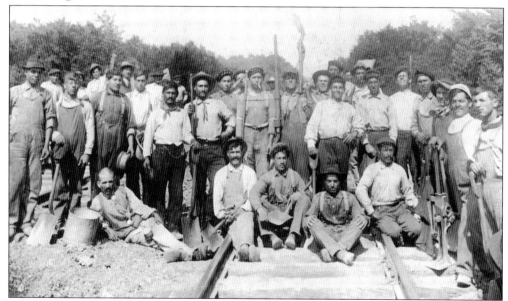

A group of railroad workers, or gandy dancers, pose with the tools of their trade—crowbars, jacks, picks, and shovels—on the Lehigh Valley Railroad. Men like these, likely new immigrants, helped lay the rails for the Lehigh Valley and other railroads that connected the country and brought industry and prosperity to early-20th-century South Plainfield.

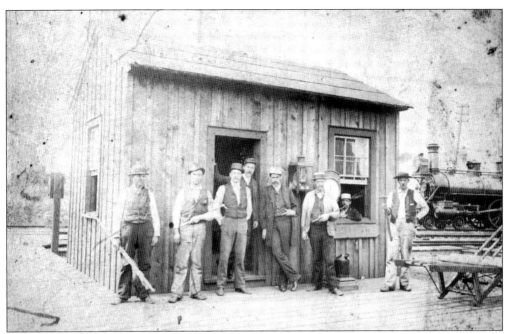

This photograph shows the LVRR's freight house around 1895. The railroad expanded operations by extending its tracks east to connect with the Jersey Central Railroad. This was known as the Jersey City Extension, though it quickly became the mainline of the Lehigh Valley.

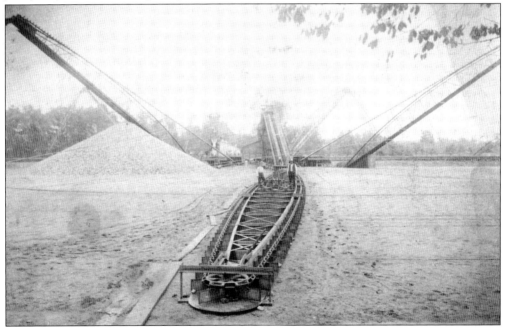

The Lehigh Valley Railroad began building the 50-acre coal storage facility on Metuchen Road around 1891. Known at the time as the largest coal depot in the world, anthracite was brought here from the Lehigh Valley and Wyoming coal regions of Pennsylvania. Superintendent of the South Plainfield Coal Storage Depot Charles Molineaux is thought to have taken this photograph in the 1890s.

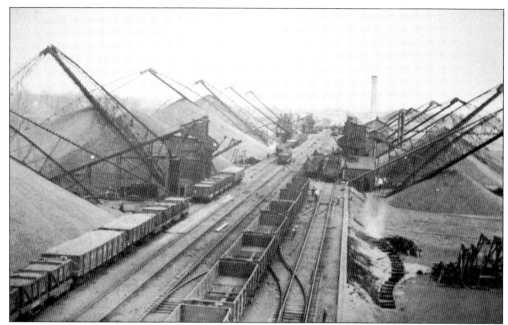

Two rows of seven pyramids of coal flank elevated tracks where train cars dumped coal in underground bins known as pockets. The coal storage facility handled five of the eight sizes of coal—egg, stove, chestnut, pea and buckwheat—and had the capacity to store an incredible 300,000 tons of coal.

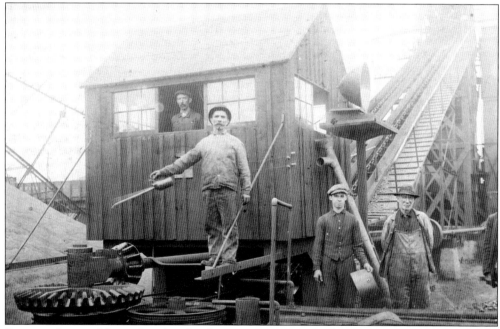

Some employees of the coal yard apply oil to an enormous gear. The Coal Storage Depot employed about 50 men. L.E. Molineux was the foreman of the yards. At peak capacity, the coal was valued at $1 million, with roughly 2,000 tons shipped a day, and half a million tons shipped in 1895. Roughly 80 percent of the coal was shipped to the New York market.

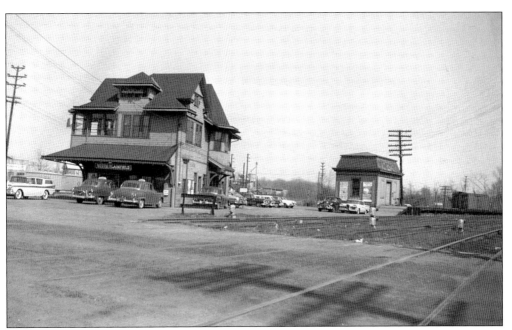

South Plainfield's Victorian-style passenger station was built in 1892. The Lehigh Valley Railroad was known for the Black Diamond Express, a luxury passenger train service between New York City and Buffalo, launched in 1896. Once a bustling transportation hub, passenger service was suspended in 1961, though freight service continued. This photograph was taken around 1970.

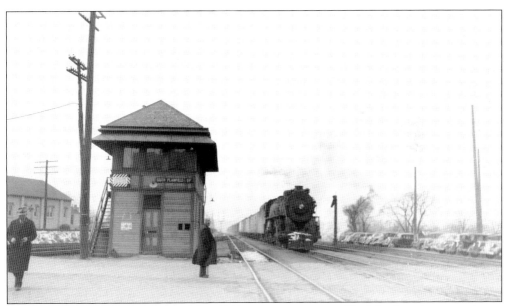

The switch tower was built in 1902. This 1940s image was captured by John Brinckmann, who, as a teenager, regularly rode his bicycle from Edison to South Plainfield to photograph the railroad. When business began declining, the tower was demolished, and operations were moved into the passenger station.

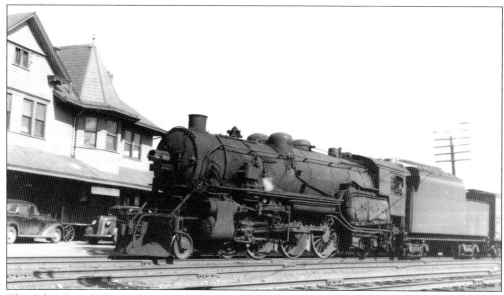

This John Brinckmann photograph shows Engine 2141 passing the LVRR passenger station in the 1940s. The valley's last day of steam came on September 14, 1951. Diesel engines replaced the old steam engines. In the 1960s, the Lehigh Valley stopped running passenger trains, and in April 1976, Conrail acquired the Lehigh Valley Railroad and many others.

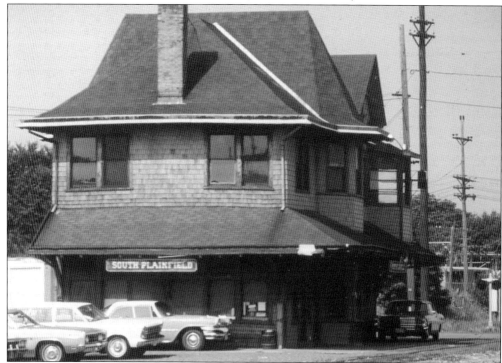

The South Plainfield train station is shown here in the 1970s, shortly before service was discontinued. As early as 1967, the borough had considered removing the passenger station as part of an extensive urban renewal program. The South Plainfield Historical Society was formed in 1975, in part to try to save the train station.

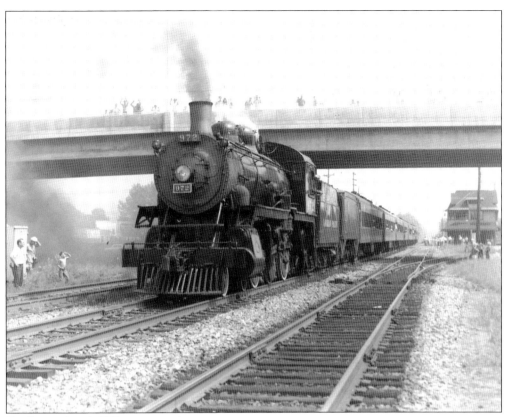

On September 4, 1971, two months after the opening of the Lakeview overpass, former Canada Pacific Railroad locomotive 972 pulls the Lehigh Valley's National Railroad Historical Society Special westbound under the new bridge. The passenger station is on the right. The neighborhood known as Castle Gardens was removed in 1970, and the overpass was constructed the following year with funding from the Public Utilities Commission and the Lehigh Valley Railroad.

In February 1977, Conrail, now owner of the railroad, demolished the derelict passenger station after futile attempts to save it by the borough and the South Plainfield Historical Society failed. Robert Bengivenga constructed a replica of the railroad station next to the rectory of Sacred Heart Church in 1986, which he called the Railroad Junction office building.

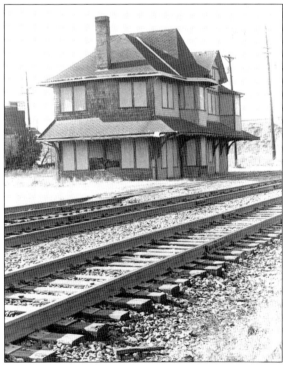

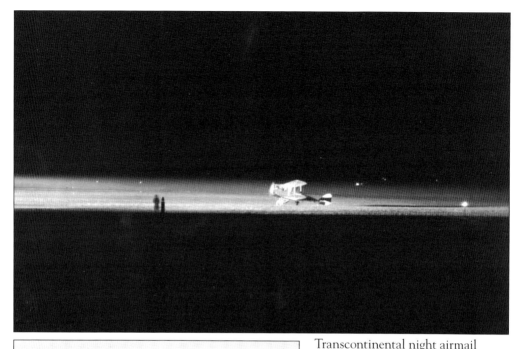

Transcontinental night airmail service from New York to Chicago was inaugurated by the US Post Office from Hadley Field on July 1, 1925. Trial night flights in June prior to the historic event attracted large numbers of motorists, who lined Stelton Road to see an aviator take off around 9:00 p.m.

B. B. T. CORPORATION OF AMERICA
Pioneers in Aviation Lighting
Atlantic Building, PHILADELPHIA, PA.

THE B. B. T. AIR MAIL FLOODLIGHT ILLUMINATING HADLEY FIELD, NEW BRUNSWICK, N. J.

AIRPORT FLOODLIGHTING

The Air Mail Type M-8-D Floodlight with either arc or 10-kw. incandescent lamp provides the most intense illumination over the entire airport. The light is evenly distributed and blinding glare is eliminated. It is economical and easy to operate, and its maximum efficiency assures its adequacy for many years to come. No other unit approaches the intensity and area of illumination produced by this floodlight.

AIR MAIL TYPE M-8-D LANDING FLOODLIGHT

AIRPORT BEACONS

The Municipal Airport of every city should have its own distinctive flashing beacon — one that flashes the code letter of the city's name. The Government provides characteristic flashes for lighthouses—how much more essential for airports to be quickly distinguished from all other lights. B. B. T. Flashing Beacons have many exclusive features not found in any other type. Make **your** airport beacon distinctly designate your city.

B. B. T. Floodlights are used with greater efficiency and economy in the illumination of: Airports and Hangars, Swimming Pools, Wharves and Docks, Excavations, Construction Work, Athletic Fields, etc.

RECTANGULAR BEAM UNITS

The type A-F-8 Floodlight is one of several smaller units using the Fresnel lens—a feature of every B. B. T. product. The beam projected by the 1000-watt lamp is in the shape of a fan spread over 180 degrees. This is a truly rectangular beam that lends itself to a wide variety of purposes.

ENGINEERING SERVICE

Complete layout for the floodlighting of any municipal airport or other project will be furnished by our experts without obligation.

TYPE A-F-8 FLOODLIGHT

1928 Municipal Index

The beacon light system employed by the government to light the field was the best available. There were 31 emergency landing fields between Hadley and Cleveland, with revolving five million candlepower lights, as well as scores of beacon lights along the route to show the pilot his exact position. Red warning lights were installed on mountain peaks and in valleys to indicate areas where it was unsafe to land.

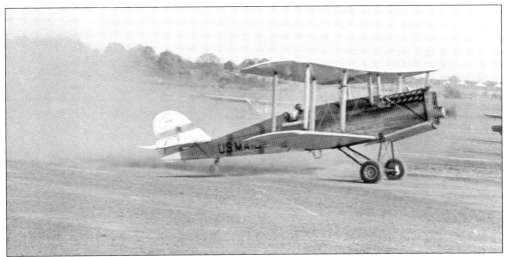

Airmail pilots flew biplanes made from wood and fabric. The cockpits were open to the elements, and they used road maps for navigational charts. Flying was a risky occupation. The US Air Mail Service averaged a forced landing every 800 miles and a dead pilot every 80,000 miles between 1919 and 1927.

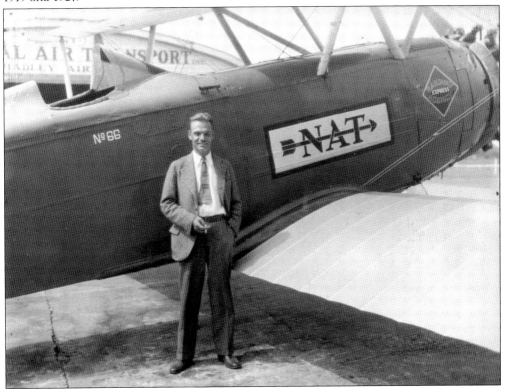

The US Post Office turned over operations of the air mail service to private contract carriers on August 31, 1927. At that point, Hadley became a general aviation field. This fellow stands by a National Air Transport (NAT) plane. NAT, founded in 1925, successfully bid on an airmail contract. The company, a forerunner of Pan American Airlines, owned a hangar at Hadley and operated 10 Curtiss Carrier Pigeon aircraft.

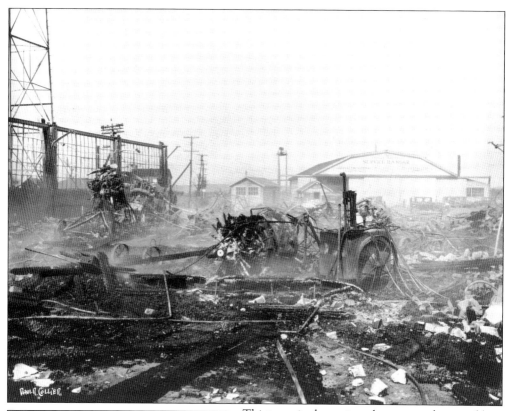

Thirteen single-engine planes were destroyed by a fire that consumed the New York Air Terminals Inc. hangar at Hadley on March 15, 1930. The loss was estimated at $200,000. Four of the planes lost were mail planes. The others were privately owned aircraft. This was a major setback for the airport, which was competing with the growing Newark Airport that had opened in 1928.

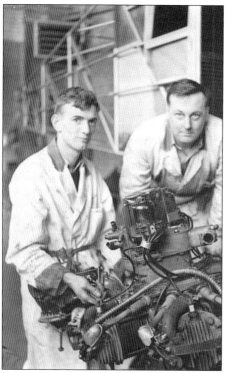

A pair of mechanics, Murphy Robertson (left) and Bill Simmons, work on an engine in one of the three hangars at Hadley Field around the mid-1930s. Murphy's brother Tom directed Hadley operations from 1932 until the airport closed in 1968.

This is a quiet, peaceful view of Hadley Airport that belies the heart-pounding aerial shows that thrill-seeking crowds flocked to see in the 1920s and 1930s. Pilots, wing walkers, and parachute jumpers gave death-defying exhibitions on weekends. Local resident Henry Apgar served as announcer for these shows and was known as the "Voice of Hadley Airport."

"Local scenic flights $2" reads the sign in this 1950s photograph of Hadley Airport. Hadley was known as a particularly safe airfield with a large, level, open field runway, no fog, and no nearby high buildings. It offered charter service, flight instruction, air taxis, aerial photography, advertising, airplane repairs, and passenger aircraft rentals by the hour or the day.

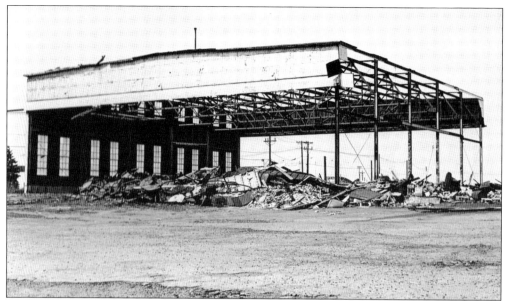

This R.K. Pederson photograph of hangar demolition at Hadley Airport on March 27, 1969, shows the end of an era. Famous flyers who flew from Hadley include Amelia Earhart, Charles Lindbergh, Clarence Chamberlain, Elinor Smith, and Thea Rache. When Smith was only 14 years old, she flew her plane under the four bridges connecting Manhattan and Brooklyn.

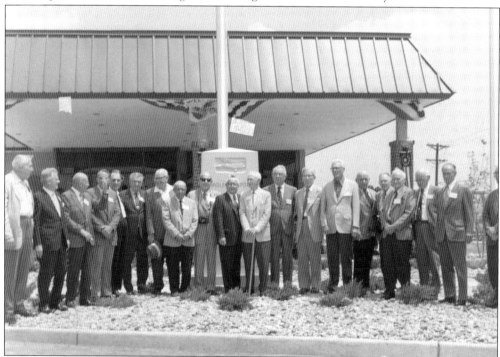

Pioneer pilots of the US Air Mail Service appear at the June 9, 1973, dedication of the Hadley Airport monument in front of the Holiday Inn on Stelton Road. Lynn Ekstedt, a South Plainfield High School student and member of the Tow Town Jerseymen, wrote an article about Hadley Field, which resulted in a state historical marker being erected at the site.

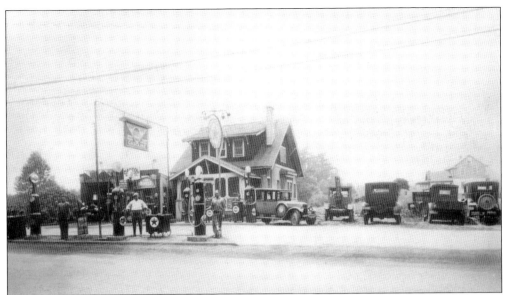

Nathan and Hyman Kadesh bought the former George Adam's Square Deal Garage on Park Avenue near the Plainfield border around 1928. Park Avenue was then only three-quarters paved, and traffic was light. The station had two pumps at the street and offered full service. The brothers, who lived in the house behind the garage, worked from 7:00 a.m. to 11:00 p.m. seven days a week. Their busiest days were Saturday and Sunday, when people went on pleasure trips.

This photograph shows the Scalera family's Standard Oil service station on Hamilton Boulevard. It was a well-known South Plainfield landmark. The enterprising family also owned a substantial bus company that provided some school bus service for South Plainfield's children.

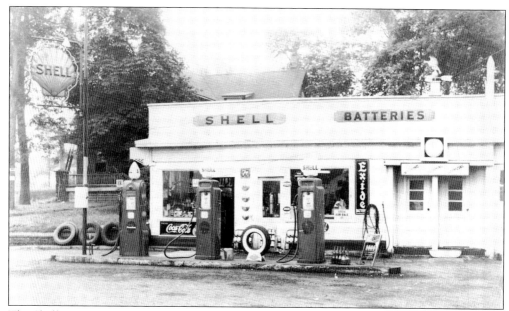

The Shell station at Maple and Lakeview Avenues stood in front of the Kaine/Van Nest house. The house, purportedly one of the oldest in town, survived the fire that destroyed the Laing/Randolph mill in 1909, but was torn down after World War II. It is now the location of the Senior Citizens Center.

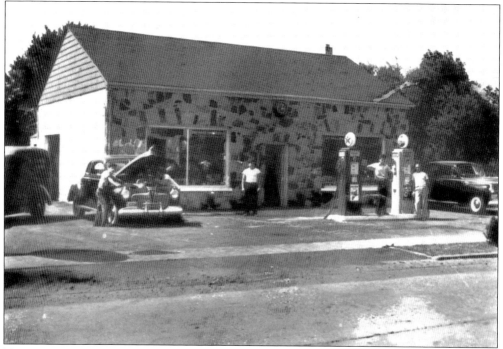

Nicastro's gas station and garage has been a fixture on Hamilton Boulevard for decades. It was initially operated by the Butrico family. Over the years, various oil companies have utilized the station, including Texaco, Crown, Flying A, British Petroleum, and Dean Oil. A father-and-son operation, Joe Nicastro and his dad have run the repair shop since the 1950s.

Five
FAMILIES AND NEIGHBORHOODS

The Niemczyk family, a true "American Gothic," is pictured here about 1930. George and Catherine Niemczyk cut hay off Oak Tree Road for their cows with Eddie, one of their 13 children. The family came from Poland in 1905 or 1906 and lived on Pine Street. The photograph highlights how rural South Plainfield was in the 1930s.

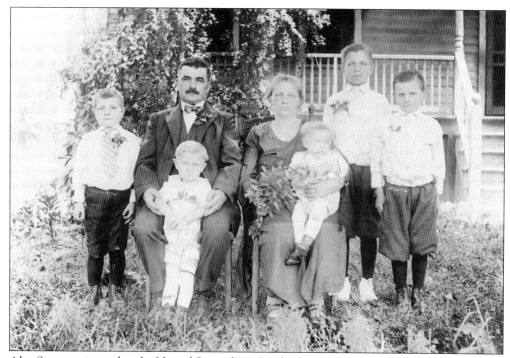

Alex Staats emigrated to the United States from Czechoslovakia in 1910. He was a crane operator for the Leigh Valley Railroad, and Mary, his wife, was a stay-at-home mom for good reason—Alex and Mary had 12 children. During World War II, six sons served in the military. This 1920s photograph shows, from left to right, Michael, Edward with his dad, George with his mother, Anthony, and John at home at 169 Front Street.

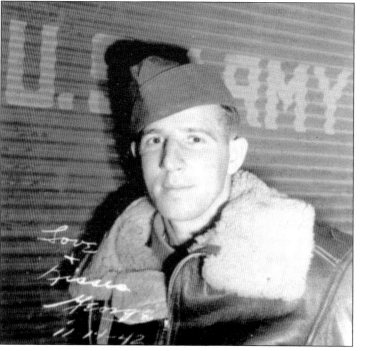

George Staats, a son of Alex and Mary Staats, is pictured in his flight jacket in November 1942. Sergeant Staats and five of his brothers served in the military during World War II, with five in the Army and one in the Navy. One brother had previously served in the Marines. They were drafted, and all survived the war.

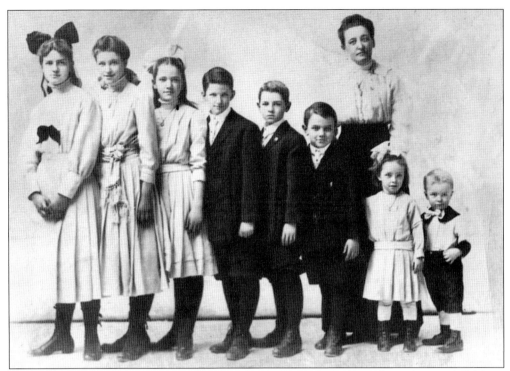

The Helmer family lived in the Holly House on West Crescent Parkway from 1922 to 1947. Marie Helmer poses with, from left to right, Mary, Eunice, Juanita, Art, Robert, Richard, Barbara, and Frank (the future admiral) in 1914. The Holly House, which likely dates from the 18th century, was originally owned by the Laing family. It still stands.

Bob Smith (left), assistant scoutmaster, and Art Helmer, scoutmaster, are pictured at Holly Park around 1930. Helmer formed Troop 1 in South Plainfield in 1925 and was active in the Boy Scouts from 1921 to 1943. South Plainfield has a strong tradition of scouting. Currently, there are three active troops in town (125, 207, and 309).

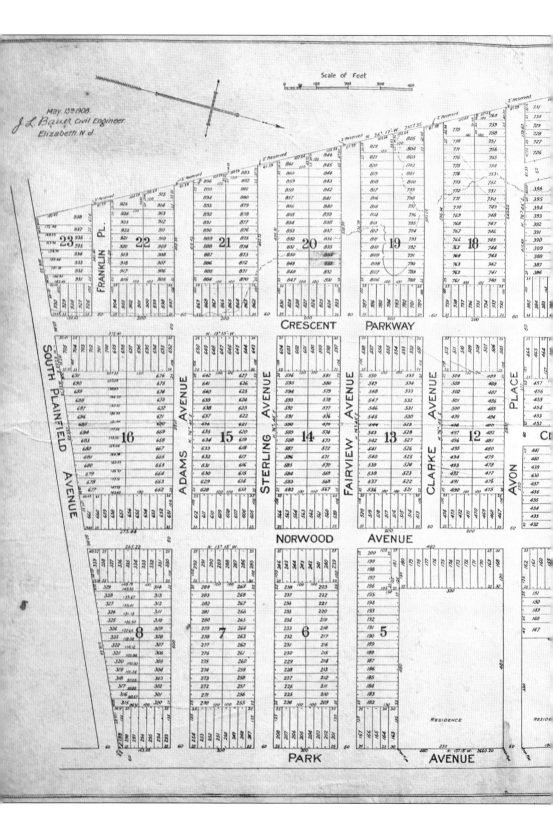

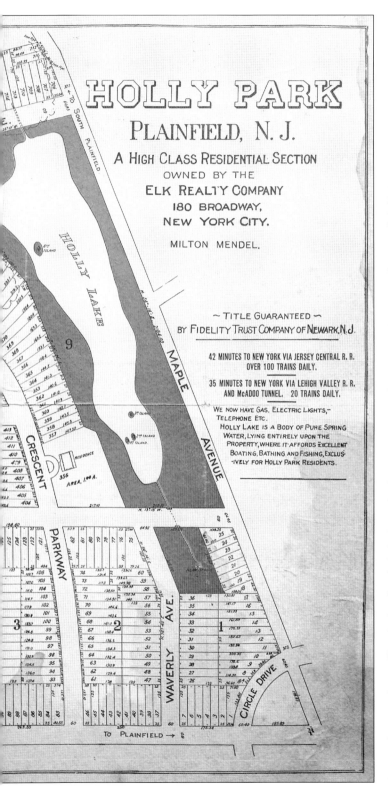

Milton Mendel, a New York lawyer and developer, purchased the former John I. Holly farm on Park Avenue, a roughly 100-acre tract, with the goal of creating a model residential community that would be part of a plan "to transform Plainfield into the greatest suburban city in the United States." Mendel expanded an existing lake that had been used for harvesting ice and planned to have boating and fishing on the lake in the summer. New deep wells providing clean drinking water were drilled. Stables for horses were going to be erected. Mendel's new houses would be furnished with running water, gas, and electricity. This map, dated 1908, shows the development between Maple, Park, and South Plainfield Avenues. Although the streets were laid out, only a handful of houses were built.

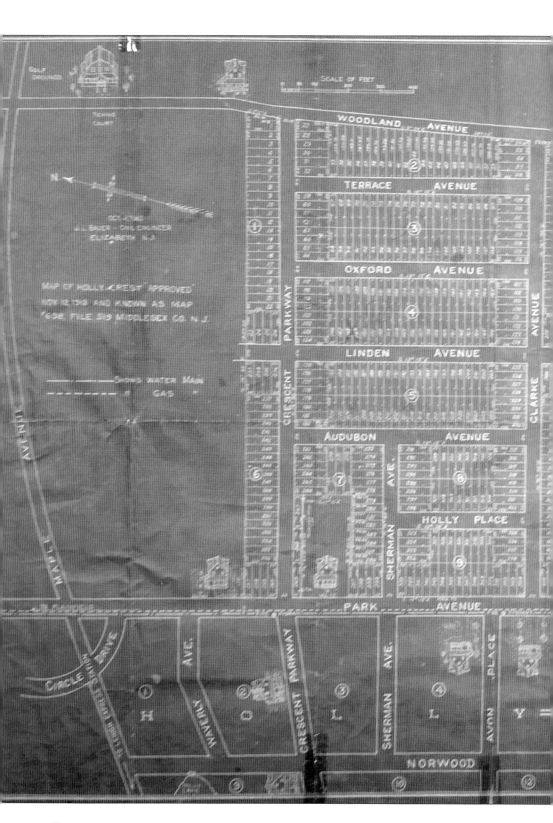

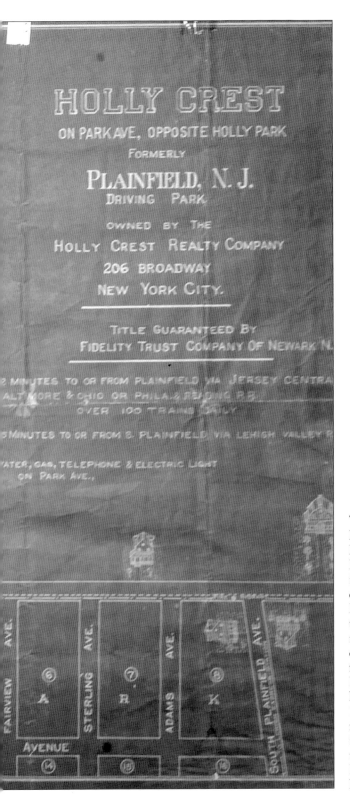

This 1912 map shows Mendel's second development, Holly Crest. Located between Park and Woodland Avenues, it occupied the former site of the Plainfield Driving Park, a roughly 40-acre tract that had a hotel and a half-mile racing track. It was once the location of county fairs. Ellis Campbell and later Thomas Brantingham had owned a hotel there. In 1909, the grandstand was remodeled and the track improved. As late as 1911, the Plainfield Racing and Driving Association was holding races at the site.

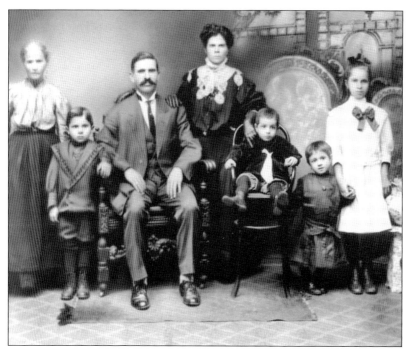

Joseph Muglia emigrated from Italy in 1902 to New York. By 1913, he had settled on a farm on Hillside Avenue where the family grew vegetables for the commercial market. Shown here are, from left to right, mother-in-law Vincenza Todera, Joseph Jr., Joseph Sr., wife Filippa, Carl, Jenny, and Anna around 1910.

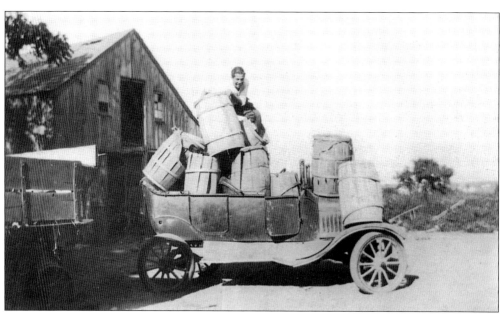

Carl Muglia loads cabbage barrels on the truck for out-of-town delivery around the 1930s. He seems to be having a good time. The Muglia farm was located on the south side of town off Hamilton Boulevard. Their home on Hillside Avenue was previously the Brantingham house and dates from the 19th century.

This is a photograph of a Pomponio family gathering in 1914. From left to right are (first row, seated) Philomena Pomponio Santoro, Angelina Pomponio (mother of all) and Eliza Pomponio Gaudiosi; (second row, standing) James Pomponio, Angeli (leaning on chair), Louis Pomponio, Michael Pomponio, and Adeline Pomponio. Michael served on the first borough council in 1926.

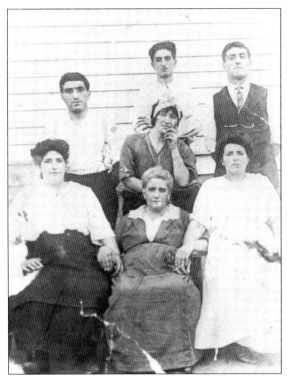

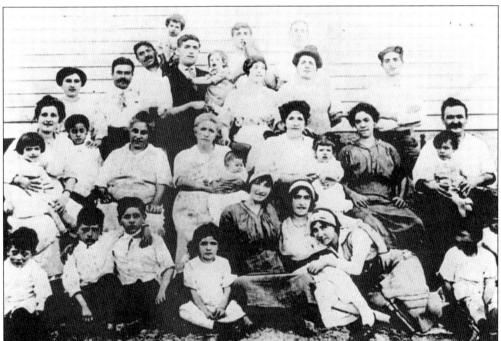

The Pomponio, Santoro, and Gaudiosi families united at Angelo DeFillipo's home on South Plainfield Avenue for the christening of Angie Santoro in 1914. Rocco Pomponio arrived in the United States from Potenza, Italy, in 1892. Vincent Santoro was the first barber in South Plainfield, and Edward Santoro was the first borough attorney.

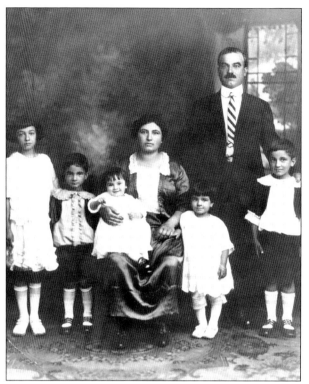

Angelo and Philomena DeFillipo are pictured with their children, from left to right, Philomena, Alphonse, Henry, Edith, and Louis. They lived at 167 South Plainfield Avenue, where Sacred Heart Church stands today, and were farmers. They raised beets, carrots, lettuce, tomatoes, and rhubarb. Several other members of the DeFillipo family also lived along South Plainfield Avenue.

A crowd of 350 people gathered on March 13, 1954, to honor Frank A. Diana in recognition of his decades of work in civic and charitable areas. Diana had served on the board of education, as a volunteer fireman, as a charter member of the Sons of Italy, in the US Coast Guard Reserve, as a member of the board of health and Lions Club, and more. He is seated with his wife, Elma, and his in-laws Lewis and May Randolph.

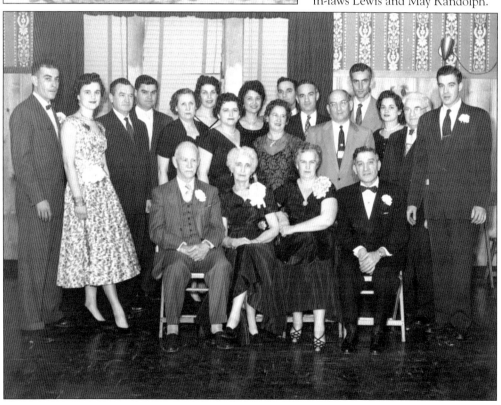

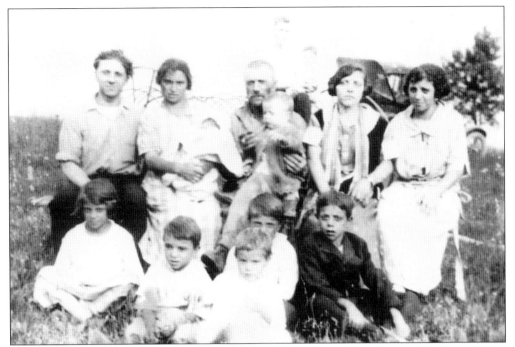

The south side of South Plainfield was a sparsely populated area when Antonio Risoli settled on West End Avenue around 1918. His home was lost to the construction of Interstate 287 in the 1960s. This 1923 photograph shows, from left to right, (first row) Alice, John, Selma, Dominic, and Nick; (second row) Peter Perone, Filamena Risoli (holding baby Louis), Antonio Risoli holding little Joe, and daughters Millie (married to P. Perone) and Jennie.

The Randolph family can trace their lineage to the early founders of Piscataway Township in 1669. Here are some descendants photographed on July 6, 1957; they are, from left to right, (first row) Charles, Turie, Florence, Louise, Lettie, and Eunice; (second row) Harry, Wilfred, Robert, Arthur, and Isaac. There were a total of 17 brothers and sisters.

This photograph, taken sometime in the 1930s, shows the Ranger family. From left to right, sons Donald, James, and Alfred Jr. stand in front of their parents, Alfred Sr. and Marguerite. Donald died in combat in 1944 at the age of 23. Alfred Sr. was active in the community, and Alfred Jr. became a well-known coach and educator in South Plainfield.

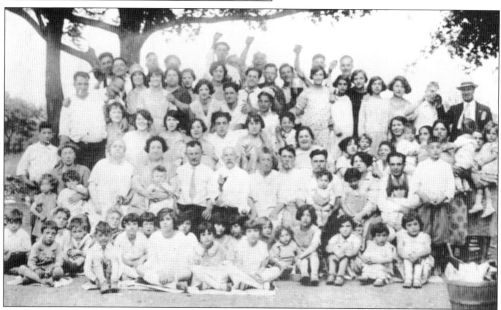

Here is a huge family gathering of the Robustelli, Caputo, Santoro, and "Big Frank" DeFellipo families of South Plainfield in the mid-1930s. Big Frank is standing at far left in black pants smoking a cigarette. Note the spelling of the name DeFellipo, which distinguishes this family from the DeFillipos who lived in the area of South Plainfield Avenue.

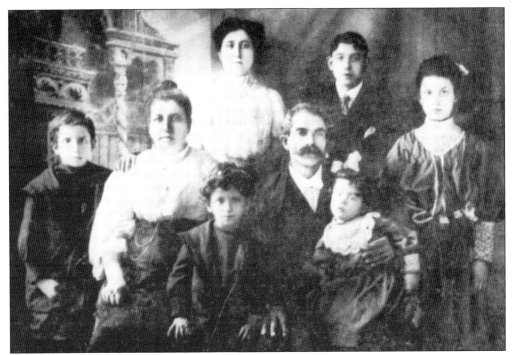

Christine Robustelli Bumback, born on the family farm on Durham Avenue, was one of nine children of Grace and Nunzio Robustelli. She shared this c. 1920s family photograph and captioned it, "Top right, Uncle Joe. Top left, my mother, Grace [DeFellipo]. Far left, Uncle Frank, Grandmother and Grandfather holding baby Julia. Far right, Aunt Kate. Middle, Uncle Mike."

The Prehodka family is shown in a c. 1930s photograph; from left to right are (first row, sitting) Martha, mother, father, Tessie, and Frances; (second row, standing) Lucy, Slim, Charlie, Ted, John, Paul, Michael, and Nina; Mr. and Mrs. Prehodka were Ukrainian immigrants who had a small farm on New Market Avenue where they raised cows, pigs, chickens, and nine kids. Mr. Prehodka was also the local butcher.

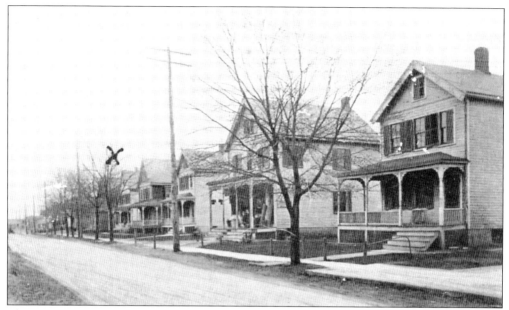

This early-20th-century postcard view shows what was called Lehigh Avenue and later became Hamilton Boulevard, which was named after South Plainfield's first mayor, William Hamilton. At first, the street took its name from the Lehigh Valley Railroad, which cut through the center of town. Although there were sidewalks, the streets had not been paved yet.

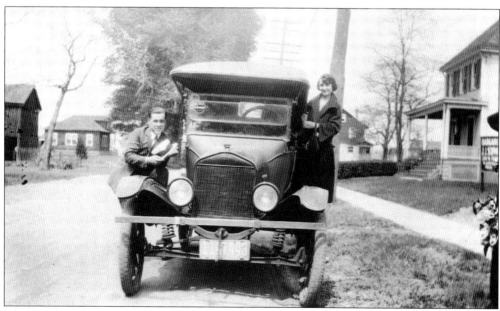

John DeLeo and his lovely companion are parked in front of 706 Maple Avenue, once known as Old Raritan Road. A corner of Tappen's ancient barn is seen at the left. During the Revolutionary War, both friends and foes marched over this dirt road to and from military engagements in the area.

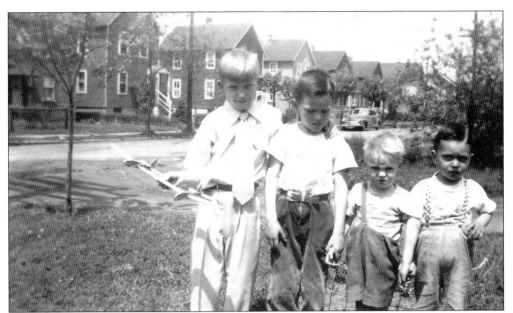

These kids lived on Lakeview Avenue. The neighborhood, called Castle Gardens, was demolished in 1971 to make way for the railroad overpass. The neighborhood's name came from Castle Gardens in New York, a precursor of Ellis Island. It was home to some of the workers at the Spicer Manufacturing plant. This photograph is from around 1950.

On January 23, 1926, Angelo Maria Mastropietro bought a tract of land (400 New Market Avenue at Pitt Street) from widow Katie Faller of Brooklyn, New York. Then, on May 12, 1926, he bought a second tract of land (404 New Market Avenue) from widow Elizabeth Rottach of Queens, New York. He built this house, and he and his family moved in around July or August 1926.

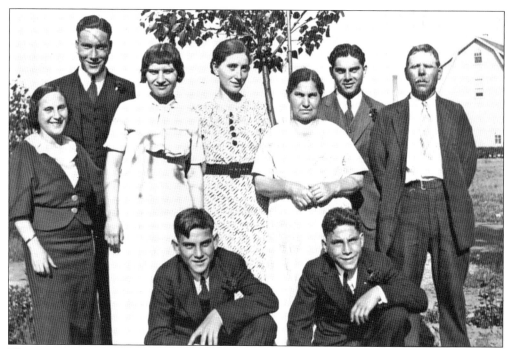

This Mastropietro family photograph, dated June 2, 1935, was taken behind their 400 New Market Avenue house. In 1939, the Polish Home and its huge parking lot were built on this property. This photograph was taken on the occasion of Mike and Joe's confirmation. Other Mastropietro family members pictured are, from left to right, Kay, John, Antoinette, Frances, Rachel, Rocco, and Angelo.

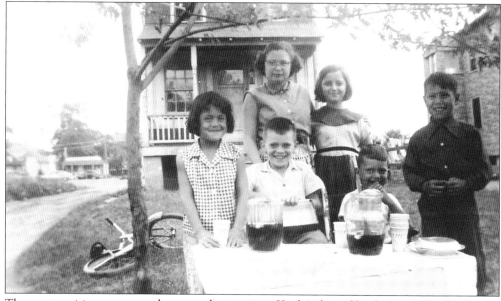

These enterprising young people seem to be running a Kool-Aid stand by the Castle Garden houses in the center of town. They are, from left to right, (first row) Gloria Madamba, Billy Burnham, Buddy Burnham, and Henry Madamba; (second row) unidentified and Nina Kurilew. This is a great scene from around 1950.

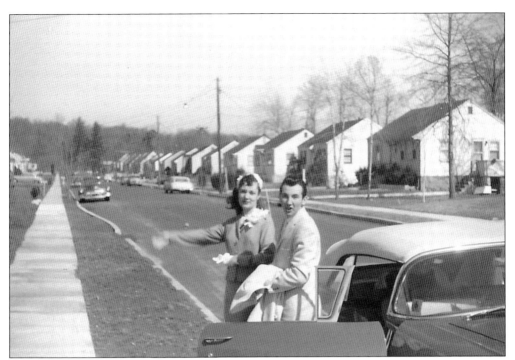

Oak Manor Parkway, another postwar development, is pictured here with a happy couple on a date in 1959. This view looks north toward Park Avenue. The development was about a decade old at the time this photograph was taken. Today, almost all of the houses have been modified and expanded.

John and Mary (DiCanto) Agrista stand in front of their Weyerhauser one-family dwelling on Garibaldi Avenue. Fourteen housing units were authorized by the state Department of Economic Development and the borough in July 1947 to help returning GIs find temporary housing. The project cost $53,000, of which the borough's share was $5,000. The houses were condemned and torn down eight years later.

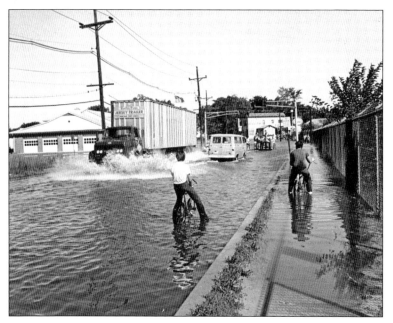

A flooded Plainfield Avenue is seen here in the 1970s. Before Spring Lake was reduced in size, this was a regular occurrence. The rescue squad is to the left, and the Lakeside Tavern, now Flanagan's, is to the right. In the 1970s, the road was reworked to move it farther west, and Spring Lake Park was constructed, reducing the danger of flooding.

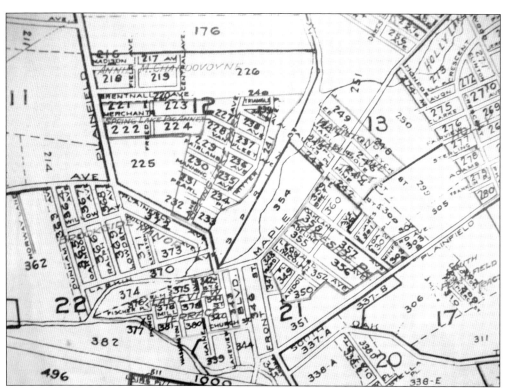

A 1929 tax assessment map denotes several neighborhood designations in the heart of the borough: Lakeside Park, Lakeview Terrace, Brookside Manor, and Spring Lake Park. Other neighborhood names include Holly Park, Holly Crest, Cherry Dell, Hollywood Farms, Muglia Estates, and Avon Park. Note that Holly Lake is still present along Maple Avenue.

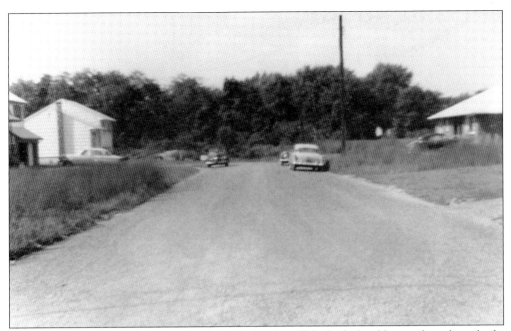

Audubon Avenue looks quite rural in 1954. Only a handful of split-level houses have been built, and the road is still gravel. This is from an album kept by the Department of Public Works showing road construction projects. The neighborhood was called Plainfield Heights. Today, it is completely built up.

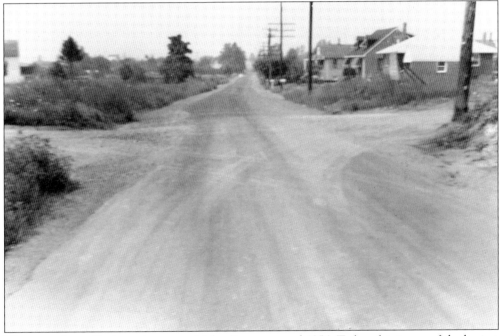

This view shows Durham Avenue at Helen Street around 1956. Today, this is one of the busiest streets in town. In 1929, the area was designated Plainfield Estates. The houses are mostly gone, replaced by commercial development, and the road is four lanes wide. The construction of Route 287 completely transformed this part of town.

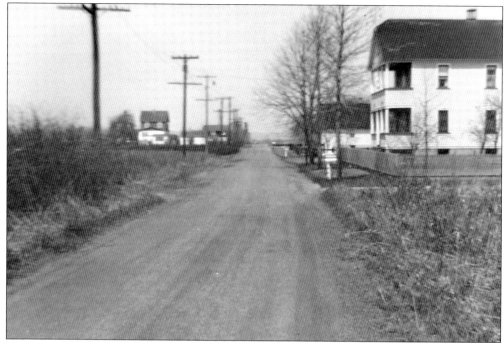

This is Kenneth Avenue by the South Plainfield Baseball Club as it appeared in 1956. Kenneth Avenue was part of the Plainfield Terrace development. The view looks north. Today, the club is on the right side of the street. These buildings still stand, although much altered.

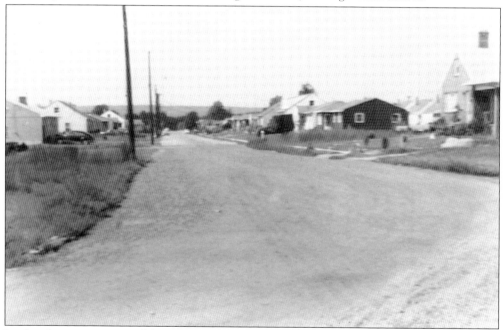

Linden Avenue was part of the Avon Park Section No. 1 on the 1929 tax map. "Avon" refers to the 19th-century circular carriage turn-around at the intersection of Maple and Park Avenues. This photograph looks north from the intersection of East Crescent Parkway and Linden Avenue. Some of the lots are still undeveloped.

Six

Education

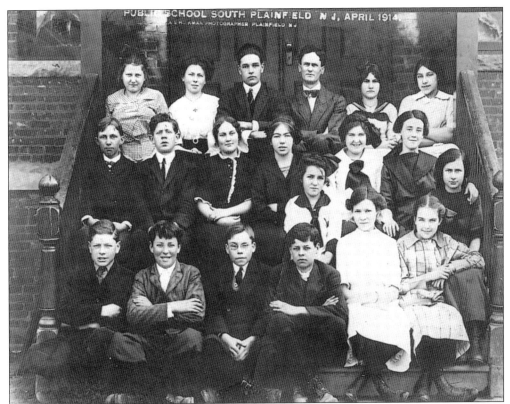

This is a class photograph from April 1914 at the old Grant School on what was then Lehigh Avenue. The school was built in 1900 and expanded in 1914 to accommodate the growing population. When constructed, it was in Piscataway Township. It closed in 1974.

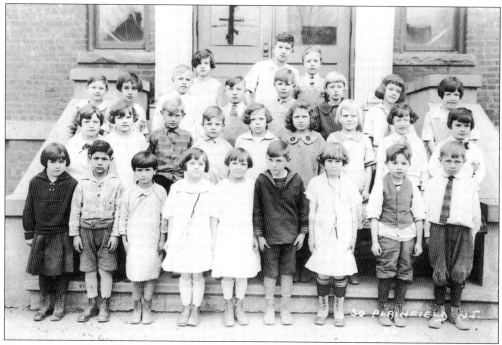

Here is another Grant School class photograph, this one dated 1923, the year after another addition was built on the school. This latest addition would become the main entrance on Front Street. Generations of South Plainfielders attended Grant School. In 1983, it reopened as Keystone Community Home, a residence for the developmentally disabled.

This building at 1324 New Market Avenue was once Columbus School. It is now AKA Inc., a screen-printing and design service company. The photograph dates to the 1970s. The school is believed to have had only two classrooms and is the least documented of South Plainfield's schools.

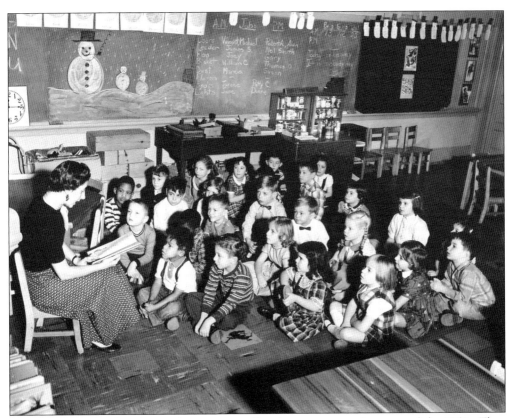

Doris Bandolyai reads to her students as part of kindergarten story time around the 1950s. They are a very attentive group. The photograph was taken at the old Grant School. The brick Grant School was constructed in 1900, replacing an earlier frame building that was moved across the street. It was expanded in 1914 and 1922.

This photograph shows a complete dental unit donated to the board of education by the South Plainfield Elks in the early 1950s. Members of the board, superintendent of schools, the nurse, and the dentist, along with principal John E. Riley (far right) accepted the donation. One wonders how the patient felt, being the center of so much attention.

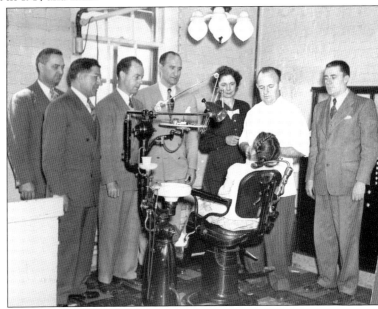

It took South Plainfield a while to build a high school. In 1949, the borough constructed a junior high school, shown here. It was expanded to serve as a high school and reopened in 1955. Previously, South Plainfield students had attended North Plainfield High School. This photograph is from a 1954 album of the high school's photography club. Today, the building serves as the South Plainfield Middle School.

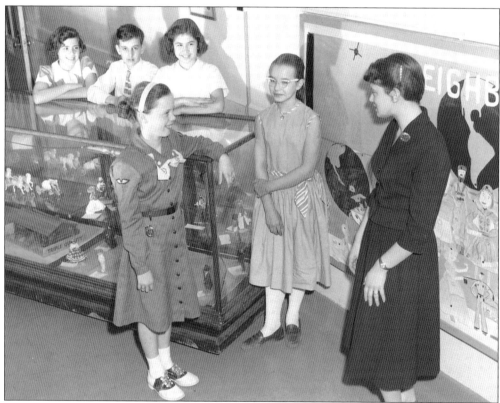

This art teacher is supervising a display case that the children are using to exhibit models they have made for a community project around 1950s. The exhibits include a log cabin built with Lincoln Logs. An assortment of dolls is also displayed. One of the young ladies is in her Girl Scout uniform.

This 1955 photograph shows principal John E. Riley with a group of students admiring a bulletin board decorated with photographs of their school. The pictures were taken by the *Plainfield Courier-News* for publication in the paper. The boy in the foreground appears to be looking at a scrapbook of newspaper articles.

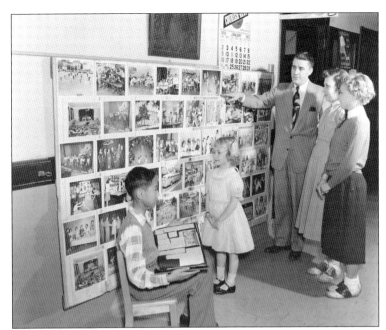

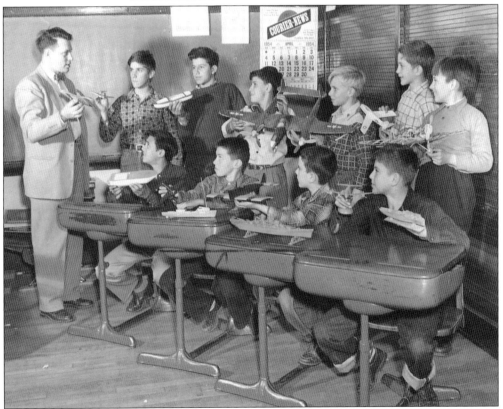

This April 1954 photograph shows Harold Wyckoff and his sixth-grade students. They appear to have been building models of a wide assortment of airplanes and boats. Wyckoff was also the first football coach of South Plainfield High School.

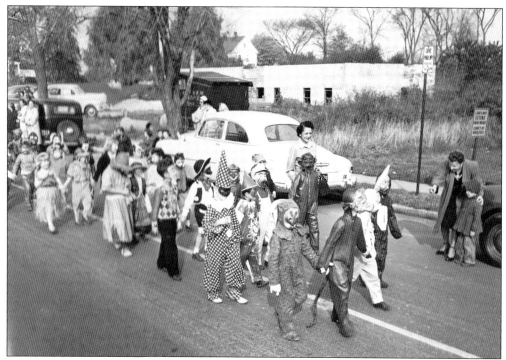

A 1950s Halloween parade marches down Front Street. The partially completed Veterans of Foreign Wars (VFW) hall is seen in the background. South Plainfield donated land to the VFW in 1947. Recently, the VFW transferred the land to Jain Vishwa Bharti for a meditation center, a transaction complicated by the way the property was originally given to the VFW.

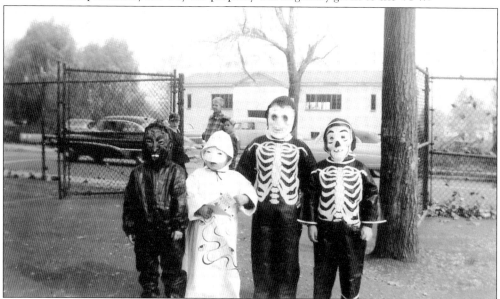

The taller skeleton in this trick-or-treating group is John Burnham, who lived on Lakeview Avenue. The VFW hall, directly across the street from Grant School on Front Street, remains under construction, dating this photograph to the early 1950s. Even today, South Plainfield's elementary schools have Halloween parades.

This little robot standing in front of Roosevelt School with a homemade costume made of tinfoil and cardboard won the most original award in the 1955 Halloween costume contest. Over 800 students in costume paraded through town accompanied by the combined high school and elementary school bands. They were escorted by the police and fire departments.

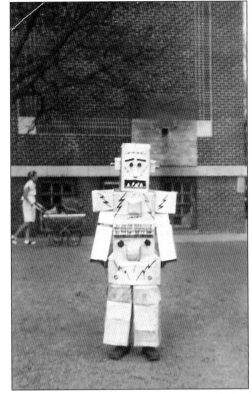

This is a 1950s photograph of officer Albert Dellavalle Jr., South Plainfield's traffic safety officer, and a group of very young trick-or-treaters with their moms. Dellavalle became an expert in traffic safety, helping to protect these youngsters and everyone else in South Plainfield. He served on the police force for 28 years.

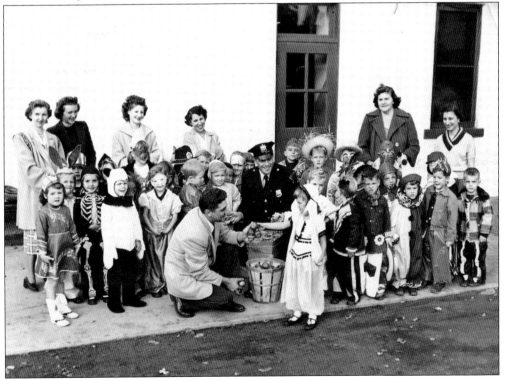

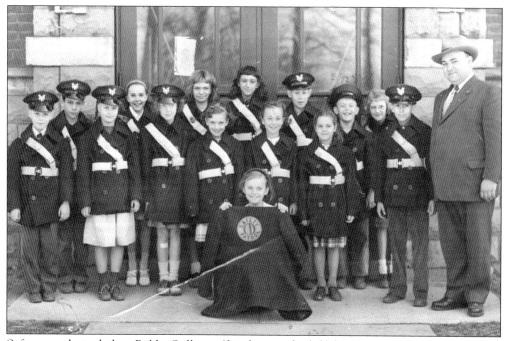

Safety patrols, including Bobby Stillman (first boy on the left) look sharp and attentive as they pose for a 1949 photograph in front of Willis School on New Brunswick Avenue. Police department captain Dominic Spinelli (right) proudly looks on. Spinelli would succeed Andrew A. Phillips as chief in 1966.

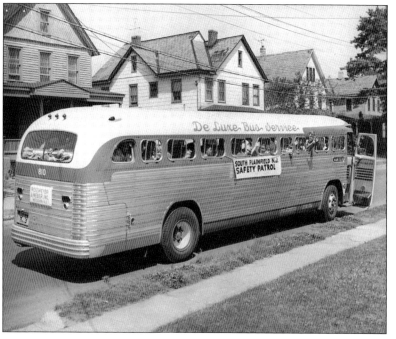

Safety patrols are ready to depart for a bus trip to Yankee Stadium to see Mickey Mantle and Phil Rizzuto play around 1955. This was one of four buses that made the trip. The photograph appears to have been taken on Front Street and the students look ready to go.

The third-grade pet show was a Grant School activity in 1954–1955. Children brought their pets to school and exhibited them in a school assembly. Here, a teacher is amused by a huge collie dog begging food from one of the parents involved in the program. This photograph was taken by professional photographer Dick Gaine.

Ellis Downing Williams was a longtime science teacher at South Plainfield High School. He received his master's degree in physics from Duke University and in 1957 began teaching in South Plainfield, where he created the school's math and science departments. He also served as a school and yearbook photographer. He retired in 1974 but remained active long thereafter.

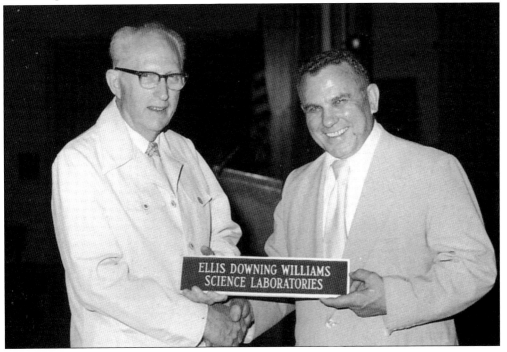

From left to right, Terry Allen, Carol Byrne, Supt. Len Tobias, and Betty McHenry accept an aerial photograph of Spring Lake presented to the high school by Ellis Williams, who took numerous photographs of the town, including several aerial views. Carol Byrne recently became South Plainfield's longest-serving school board member, having served for 22 years.

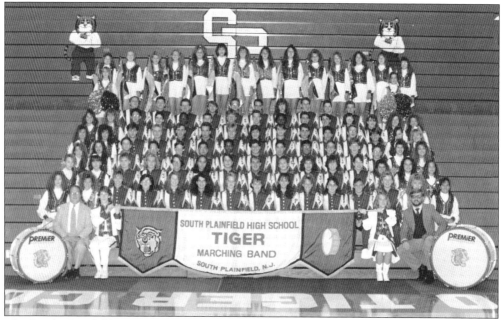

The South Plainfield High School marching band is shown here in 1991, with Joseph Tenore as director. During Tenore's tenure, the marching band grew, and the band's musicians competed locally as well as in California and Ireland, even marching in Dublin's St. Patrick's Day Parade. South Plainfield continues to have a strong marching band program.

Seven
In Service

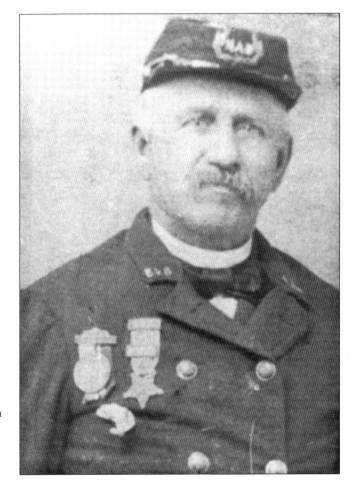

Pvt. Edward B. Austin, born in New York City in 1842, served with the 82nd New York Infantry Volunteers during the Civil War. He enlisted at age 19 in July 1861 and was captured at Bristol Station on October 14, 1863. Austin was imprisoned at Andersonville, Georgia, and paroled in February 1865. Austin spent his final years with his son Floyd Sr., Floyd's wife, Daisy, and their children in South Plainfield. He died in 1922 and is buried in the Soldiers' Plot in Hillside Cemetery, Scotch Plains.

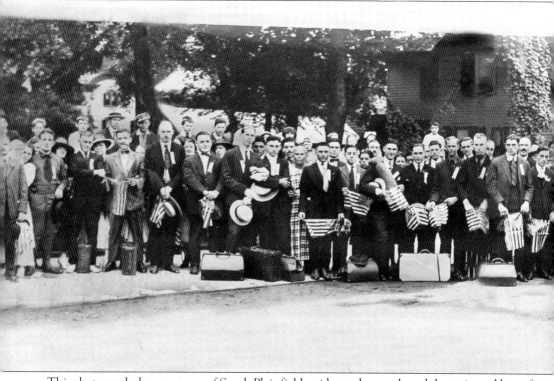

This photograph shows a group of South Plainfield residents about to board the train and leave for basic training during World War I. It is believed to have been taken in Plainfield. The photograph was donated by the family of Frank Diana Sr. One of the recruits is holding a sign that reads,

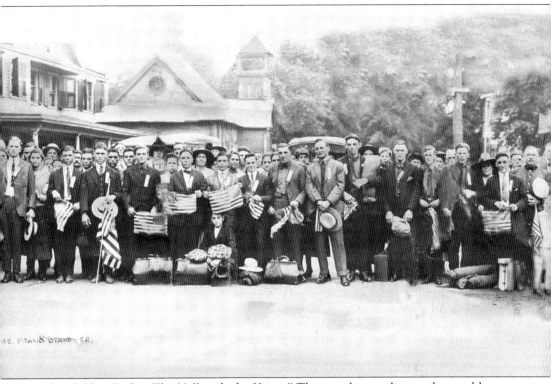

"From Plainfield to Berlin, The Hell with the Kaiser." The men have valises and several have bedrolls. The photograph is dated August 1918 and was taken by noted Plainfield photographer Paul Collier.

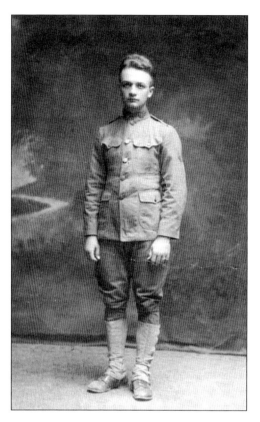

Cpl. John "Jack" Ball of Metuchen Road served in the American Expeditionary Force during World War I. He was assigned to the Base Surgeon's Office in Bordeaux, France. His wartime letters survive in the collections of the South Plainfield Historical Society and provide a glimpse of life in the area during World War I.

George Loupassakis, a veteran of World War II, married a local girl, Jeanne Pyatt, in 1940. During the war, George was stationed in Minnesota, Wisconsin, and Illinois before going overseas to India and China. Starting in 1965, the couple ran an insurance and travel agency on Park Avenue, Park Travel, for many years. Jeanne was also active in the South Plainfield PTA.

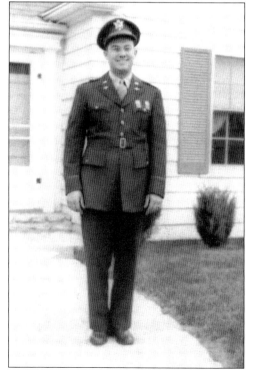

Joseph Kenney was a member of the 501st Parachute Infantry Regiment of the 101st Airborne Division during World War II. He held the rank of platoon sergeant. Kenney served as a jump master during the invasion of Normandy in June 1944. He received two Purple Hearts during the invasion and a third at the Battle of the Bulge in Bastogne, Belgium. He was a life member of the VFW Memorial Post No. 6763 of South Plainfield.

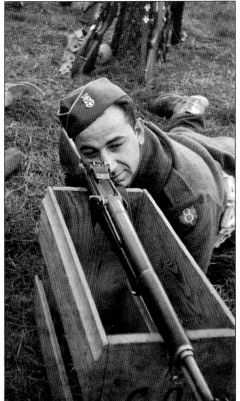

Louis DeFillipo sights a gun during target practice during World War II. DeFillipo was a decorated war hero, having been awarded the British Military Cross, Silver Star, Bronze Star, and other commendations. He was also captain of the South Plainfield Fire Department and active in the Elks and numerous other organizations.

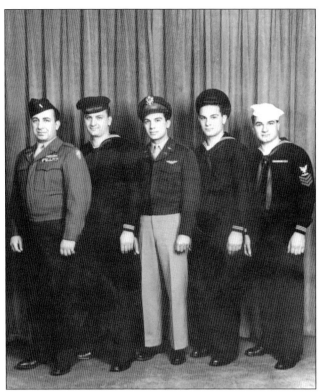

The DeFillipo brothers are pictured here during World War II. From left to right are Louis, Enrico ("Henry"), Vincent, Arthur, and Alphonse ("Chick"). Louis volunteered in March 1941; he was wounded twice and promoted to sergeant. Henry was in the US Coast Guard and was stationed stateside, Vincent was in the Army Air Corps., and Alphonse served as an ordnance officer on an aircraft carrier in the Pacific.

Len Riccardi, (first row, second from right) was a member of this B-29 flight crew during World War II. After the war, he learned to fly at Hadley Airfield's Decker Flying Service, receiving his pilot's license in October 1947. He also became an officer on the South Plainfield police force.

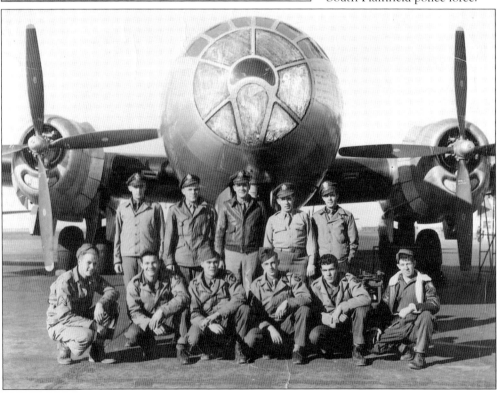

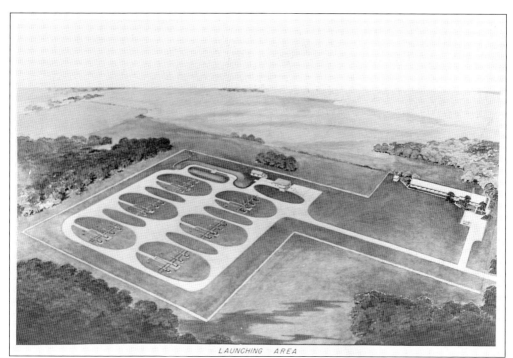

South Plainfield was once home to Nike Missile Base NY-65. The missile battery was located on Stelton Road, while the control center was on Durham Avenue. The site was located just south of Hadley Airport. One of a ring of similar bases in the New York metropolitan area, the base was first manned in 1955 and closed in 1971. Nike missiles were intended to intercept Soviet bombers carrying nuclear bombs. This illustration shows a typical base.

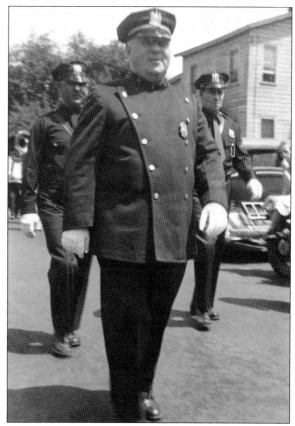

Chief of Police Cornelius J. McCarthy began his career in law enforcement in Plainfield in 1907. He also served as chief of police of the Piscataway Police Department. He became South Plainfield's first chief with its incorporation in 1926, remaining in that position until his death in 1947. This photograph was taken on July 4, 1939.

Chief Andrew Phillips leads the police contingent in a parade marching along Hamilton Boulevard. He became the borough's second chief on July 4, 1948, succeeding McCarthy. The man who would later become South Plainfield's third chief in 1966, Dominic Spinelli, is second from right. Note the train station, freight house, and Cornell Dubilier factory in the background.

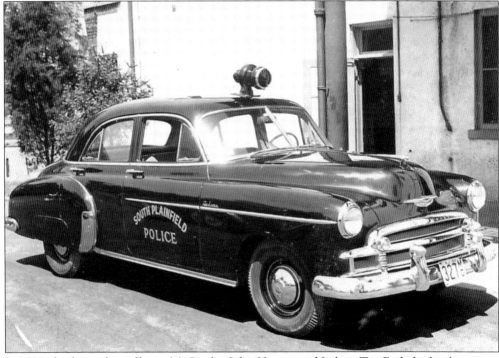

In 1926, the first police officers, McCarthy, John Hogan, and Judson Ten Eyck, had only one car and a motorcycle at their disposal. Later, when this photograph was taken, the department had made progress with its vehicle fleet. The car is a Chevrolet with an incredible spotlight on top and a great hood ornament.

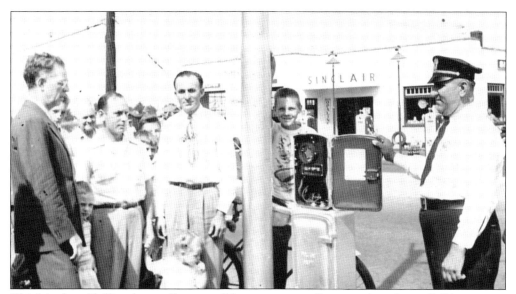

Chief Andrew Phillips shows off a new call box to a group of interested residents. Call boxes were particularly important before most houses had phone service and cell phones had not been invented. In order to alert the fire department to an emergency, people went to the closest call box.

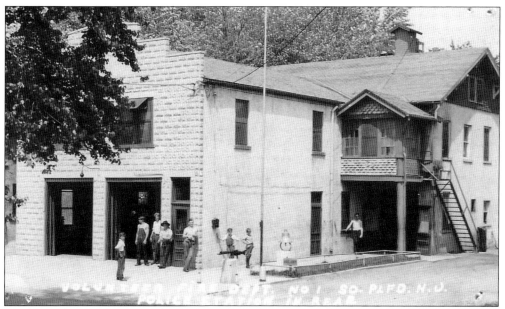

The borough rented space in this building, the firehouse on Hamilton Boulevard, for municipal offices and the police department until 1961, when the new borough hall was constructed on Plainfield Avenue. At times, it has been a frame shop, a carpet store, and a dance studio. More recently, it was a furniture refinishing shop.

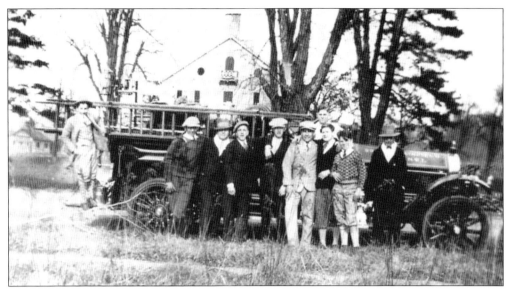

This is a very early South Plainfield Volunteer Fire Department photograph taken on Plainfield Avenue. The department was founded in 1907, in response to the growth of the community and especially the arrival of new industries, including the coal yards and the Spicer plant. The vehicle in this photograph is labelled "Truck No. 1."

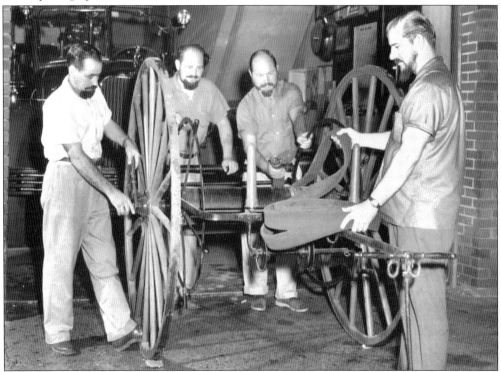

For the 50th anniversary of the fire department in 1957, firemen grew old time sideburns and beards to honor the department's founders. From left to right, the firemen are Leonard Melillo, Robert McAllister, Frank Bumback, and Leo Grabowski. The hose reel shown was either hand or horse drawn. Over 12,000 spectators came to a parade celebrating the anniversary.

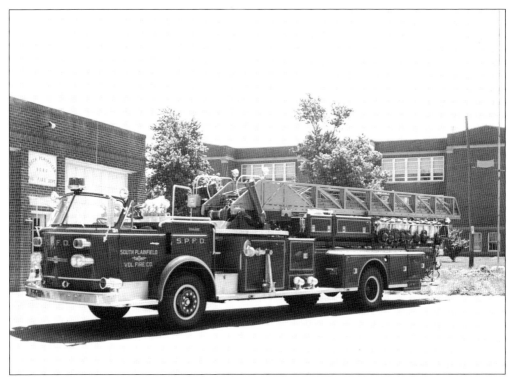

This aerial ladder truck, purchased in 1967, cost the borough $57,000. It is parked in front of the South Side Fire House on Hamilton Boulevard, across from the old Roosevelt School, around 1950. Often, fire trucks were delayed responding to south-side emergency calls because train traffic on the Lehigh Valley grade crossings blocked them. The South Side Fire House was built to mitigate this problem.

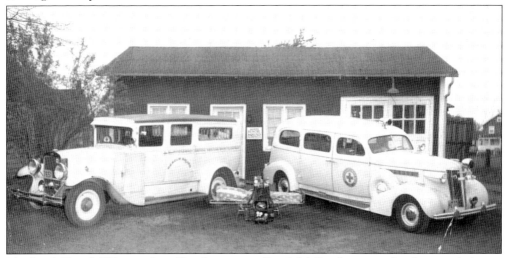

The South Plainfield Rescue Squad headquarters on Randolph Road is pictured with two ambulances parked in front around the mid-1950s. The rescue squad was organized in 1944. Frank Diana helped secure the first ambulance from the Cornell-Dubilier Company. One of the vehicles in this photograph appears to be a repurposed hearse. One wonders how patients reacted when it arrived on the scene of an accident.

The South Plainfield Rescue Squad was founded by a group of local first aid volunteers initially involved with civilian defense during World War II and was dedicated to "render such service to the public as will lessen suffering, and aid in preserving life." Shown are junior squad members around 1950. Flannel seems to have been very popular.

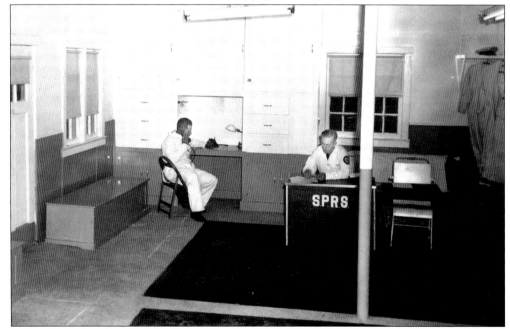

This is an interior view of the first rescue squad building on Randolph Avenue. It began as a one-car garage that was repeatedly expanded as the town grew. The original building was in use until 1965. The rescue squad made do with used vehicles until 1957, when it acquired a new Cadillac ambulance.

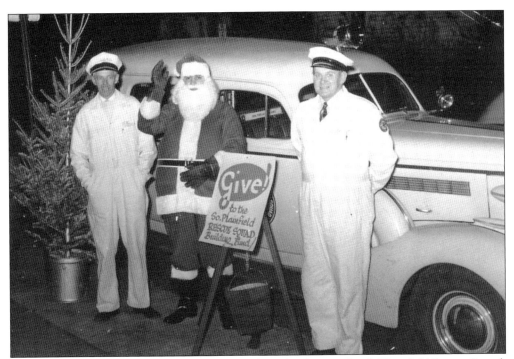

This image was captured during a holiday fund drive for the new South Plainfield Rescue Squad. The squad building on Plainfield Avenue replaced the earlier Raritan Road facility. Several lots were purchased in 1961, and in 1966, construction of the new building began. The new headquarters was dedicated in June 1967 and is in use to this day.

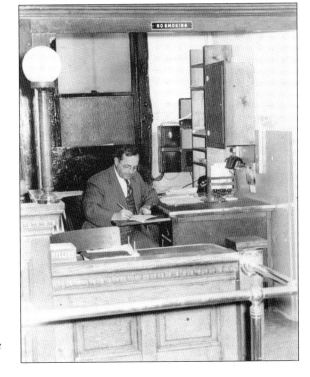

Borough clerk Charles Carone is in the old borough hall/police station/tax office in 1940. Carone was an enterprising man. He worked for the Lehigh Valley Railroad and was also clerk for the board of education for 28 years, retiring in 1954. He was one of the first two municipal employees and was in part responsible for the borough's incorporation.

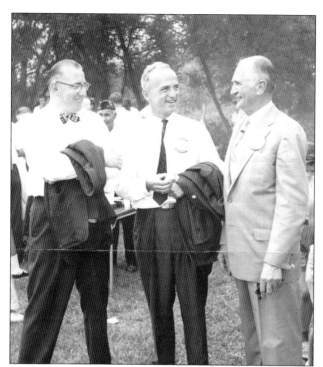

This c. 1958 photograph shows Mayor Robert Baldwin, Congressman Peter Frelinghuysen, and former mayor Peter Kaymowics. Baldwin, a talented commercial artist, designed the borough's official seal and the original veterans' war memorial, which formerly stood in front of borough hall and is now the centerpiece of South Plainfield's Monument Park.

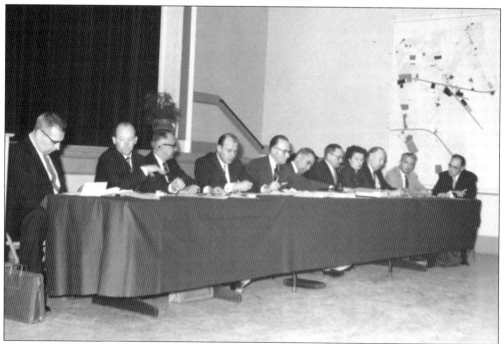

The borough council deliberates around 1956. From left to right are Henry Decker, Jim Caulfield, Tom Smith, attorney Joseph Doran, Mayor Henry Apgar, Leonard Capraro, clerk Charles Carone, secretary Margaret Schionning, Thomas Liddle, Bill Ryan, and auditor Arnold Rosenthal. By the 1950s, South Plainfield was growing by leaps and bounds as new residential developments sprang up in the postwar period.

Eight
COMMUNITY ACTIVITIES

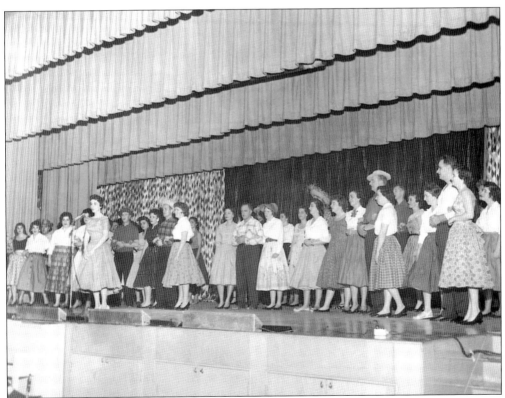

Members of the Suburban Women's Club and the Lion's Club of South Plainfield present *Oklahoma*, one of many rousing performances utilizing the combined efforts of both civic organizations. This 1950s performance was at the old South Plainfield High School, currently the middle school.

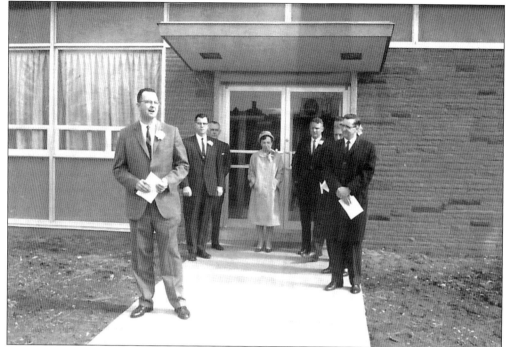

On March 17, 1965, South Plainfield Memorial Library formally opened. It was previously located in Grant School. Pictured at the dedication ceremonies are library board president Frank Williamson, library board member Frank Cornell, architect John Homlish, library director Catherine Pendola, board member George Anderson, Rev. Alfred T. Sico of Sacred Heart Church, and Reverend Sweet of Wesley Methodist Church. Out of camera range is Mrs. Edwin Dayton and Mayor John George.

A long-standing borough tradition is the Easter celebration, when children meet the Easter Bunny and gather chocolate eggs. This one was held at Veterans Park, also known as Borough Park, on April 5, 1958. Today, the Easter egg hunts are held at the Police Athletic League (PAL) on Maple Avenue and are as popular as they were 50 years ago.

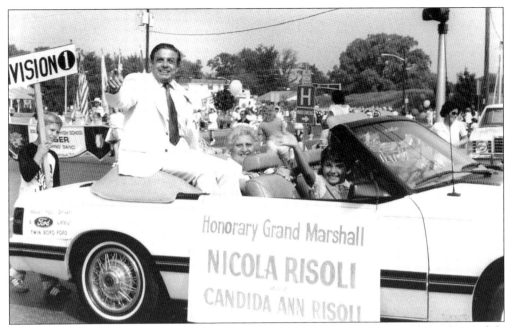

Nicola Risoli, grand marshal of the 1983 South Plainfield Labor Day parade, and his wife, Candida Ann (Fittipaldi), led the marchers. Risoli was one of five brothers in the Army during World War II. Corporal Risoli, a combat engineer with the 106th infantry, fought at the Battle of the Bulge and was an ex-POW. He was a longtime advocate for veterans' rights.

Rev. Charles Mingle, grand marshal of the 1986 South Plainfield Labor Day parade, is shown here at Spring Lake Park. A World War II Navy veteran, Mingle was pastor of St. Stephen's Lutheran Church from 1963 to 1989, fire department chaplain, and was involved with the Boy Scouts and the historical society. He is a beloved member of the community and a counselor to many.

This is a teepee made by Boy Scout Troop 1 of Holly Park on the Helmer lawn on Crescent Parkway around 1928. The teepee burned to the ground due to an unattended campfire. Indian lore and camping are still important in Boy Scouts. Art Helmer was the longtime scout master of Troop 1, beginning in 1924 and retiring in 1943.

A group of South Plainfield Girl Scouts are pictured on the steps of the US Capitol in Washington, DC, on August 6, 1965. The Girls Scouts were very active in the 1960s under the leadership of Mary Mazepa, second from right, and others. Trips to Washington, the Statue of Liberty, and numerous community service projects kept the young ladies very busy.

The Girl Scouts from Troop 620 beautify the downtown area at the corner of S. Plainfield Avenue and Hamilton Boulevard on May 16, 1968. They are, from left to right, Dianne Mocharski, Joan Perch, Peggy Lyons, and Gail Grogan. This corner was once the site of the Ryno homestead; later, a bank was built there, and more recently, it served as an emergency management building.

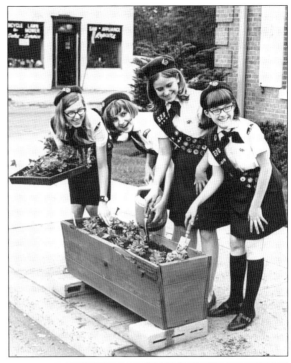

Louis DeFillipo (left) is handed the gavel as the new exalted ruler of the local Elks lodge. Founded in 1963, Lodge No. 2298 met in several different locations, including Kane's Bar and Spisso's, before moving to its current home on New Market Avenue in 1988. DeFillipo was one of the founding members.

South Plainfielders are parade lovers and parade-goers. This parade took place July 4, 1939. Here, an entry passes the Garden State Grocers on Hamilton Boulevard at the intersection of New York and Camden Avenues. The borough's first documented parade took place on Independence Day 1907. Today, South Plainfield is known for its Labor Day parade.

Charter members of the Rotary Club of South Plainfield are pictured here in 1938. From left to right are (first row) Paul Archibald, Ed Santoro, Bill Nischwitz, and Lou Churchill; (second row) Frank Santoro, Abe Pass, Charles Curreri, Dan Geary, Henry Brentnall, Adam Phillips, Emanuel Gauci, Walter Connors, Ben Vail, and Anthony DeAndrea; (third row) Sonny Beyer, Sam Jordan, Dunham Reinig, Harry Fries, and N.A. Helmer Sr.; (fourth row) Al Robbins, Al Leury, and Harold Eaton.

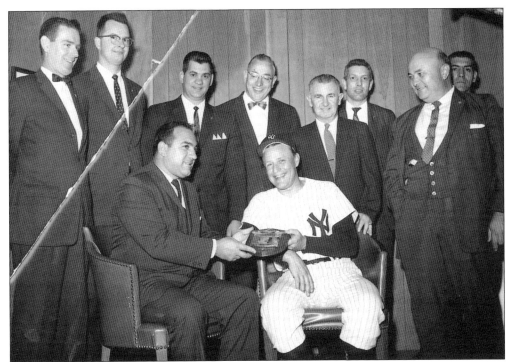

The PAL presents a plaque to New York Yankees skipper Ralph Hauck for the team's contributions to youth. Standing from left to right are Councilman Richard Kennedy, Frank Williamson, Anthony Cataldo, Mayor Robert Baldwin, Nip Sofield, Jim ?, Dominic Spinelli, and Albert Dellavalle Jr. Seated with Hauck is Tulio "Cappy" Capparelli.

As the famous quote states, "Neither snow, nor rain, nor heat, nor gloom of night, stays these couriers from the swift completion of their appointed rounds." This postal employee's retirement dinner was attended by, from left to right, postmaster Joe Ferraro, postmaster Anthony Fittapaldi, carrier L. Cetrulo, postmaster John Kane, postmaster John Sideck, and postmaster R. Adams.

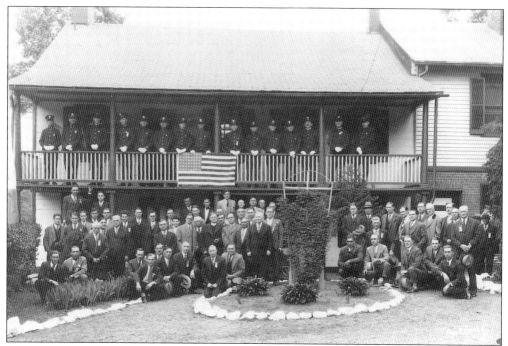

A veritable who's who of South Plainfield is in this photograph of the Sacred Heart Holy Name Society in 1929. Members are gathered at the Washington House, a popular local eatery in Watchung. Nearly all the faces have been identified on an enlargement at the South Plainfield Historical Society's History Center.

Mayor Robert Baldwin, with clerk Charles Carone beside him, signs a contract for construction of Borough Hall on Nov. 10, 1960. Standing from left to right are local businessman Ben Fein, attorney Angelo Dalto, building inspector Louis Spisso, council president James Caulfield, tax collector John Bori, Councilwoman Patricia Lauber, Councilman Richard Kennedy, Councilman Charles Lammers, and Councilman Anthony Mondoro.

Nine
Sports and Recreation

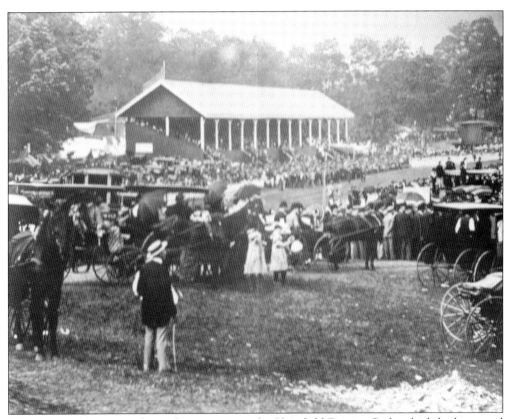

A huge crowd is in attendance for an event at the Plainfield Driving Park, which had reserved seating in the grandstand for the social elite. For over 40 years, the most prestigious horses and riders on the East Coast exhibited here in hunter, jumper, equitation, driving, and steeplechase classes. The site was located off of Park Avenue.

Guillermo Thorne was a prominent Plainfield photographer in the late 19th and early 20th centuries. He photographed the Middlesex and Union County Fairgrounds (also known as the Plainfield Driving Park) on Park Avenue around 1890. An oyster bar has been set up to feed the

crowd. The building in the rear was the Women's Christian Temperance Union. Note the large crowd and all the carriages. (Donald Lokuta.)

Joe Scalera heads his trotter to the finish line at Borough Park track, located between Franklin and Tompkins Avenues. The Central Jersey Horseman's Association organized races for trotters and pacers in the 1930s. Even today, digging in the backyards of houses in this neighborhood reveals sand from the track.

These teens saddle up at Charlie Young's stable at the corner of Hamilton Boulevard and South Clinton Avenue in 1958. The riders are, from left to right, Dorothy Obley, Judy Laurence, and Sandy Pasik. The area has changed considerably over the last half century.

The Buccaneers, a sandlot football team, are playing on the field in front of Walgreens around 1938. The big game was always played on Sunday, and the town came out in support. Today, it is hard to imagine that there was once a field in the center of town.

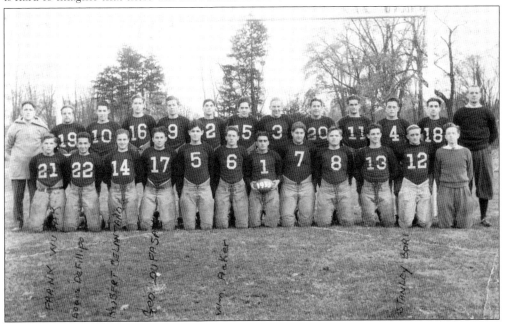

Before the South Plainfield High School was built, students attended North Plainfield High. This 1933 North Plainfield team includes several South Plainfielders: C. Gubernat (19), N. Cataldo (10), J. Sideck (9), C. Thornton (15), E. Spisso (4), V. Benicasso (18), F. Wutuak (21), Lou DeFillipo (22), H. Celentano (14), W. Acker (6), R. Dorosh (7), G. Loupasahis (17), and S. Bori (12).

Mary Caffrey (left) and Marge Staats skate on Spring Lake in 1942. Note the Lakeside Garage in the background (now a Mobil gas station) and the Lakeside Tavern, now Flanagan's. Spring Lake was larger then and a popular spot for skating, fishing, and boating. There was even a shop that sharpened skates.

Vinnie Pellegrino peers through the boat's window as his dad and uncle cruise on Spring Lake in the 1940s. Today, with the lake much smaller, this would be impossible. The Middlesex Water Company owned the lake from 1897 to 1974, when Middlesex County purchased it. Roughly a decade later, the county began work on Spring Lake Park.

Three of the winners at the 1985 Annual Fishing Derby, sponsored by the Recreation Commission at Spring Lake Park, are, from left to right, Cindy Wytho, Matthew Lowicki, and Michelle Crawford. Behind them, from left to right, Councilwoman Addie Levine, Teddy Biribin, and assistant recreation director Bill Nothnagel look on. Fishing in Spring Lake Park remains popular today.

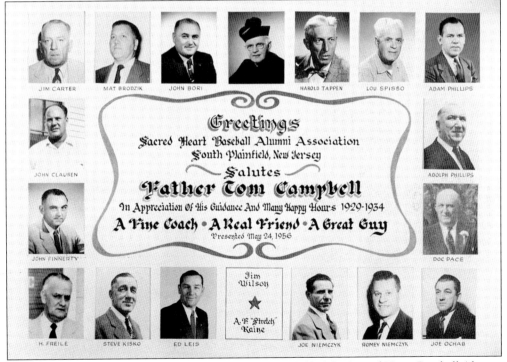

This invitation to a testimonial dinner for Fr. Tom Campbell of the Sacred Heart Baseball Alumni Association is a who's who of early 20th century South Plainfield. Harding was pastor of Sacred Heart Church from 1944 to 1951. A popular priest, he was also a major advocate for youth sports and began the planning for Sacred Heart's parish school, now Holy Savior Academy.

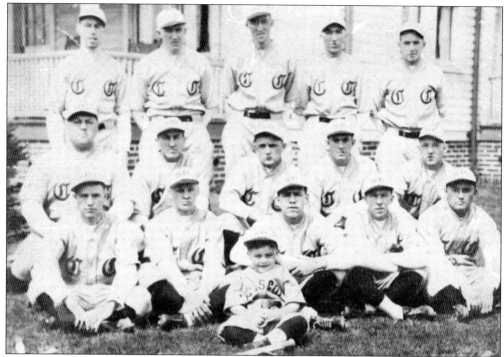

The Sacred Heart baseball team is pictured on the lawn of the Lehigh Hotel at the corner of South Plainfield Avenue and Front Street around 1930. The hotel was owned by the family of Phil Lippitt, the team's mascot (center). The Lippitts had a baseball uniform–making business on the premises after Prohibition forced them to close their bar.

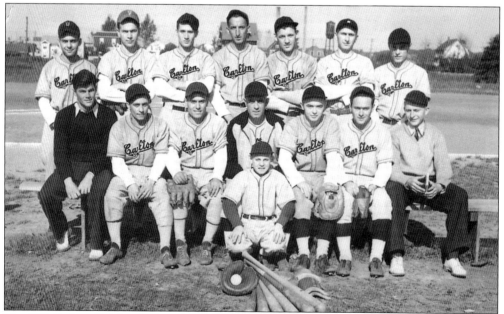

The 1933 Carlton Club baseball team consists of, from left to right, (first row) G. Kostick, J. Cirigliano, R. Cirigliano, Lou Spisso, K. Leary, M. Spisso, and J. Leach; (second row) J. Tombro, John Sideck, W. Acker, T. Krochuk, J. Spock, F. Leach, and A. Cortazzo. The bat boy in front is Joe Spisso.

A testimonial softball award dinner at the Polish National Home in 1947 honored John Sideck, a talented athlete who earned letters in baseball, basketball, and football. A World War II veteran, he also served for 42 years as the South Plainfield postmaster. From left to right are Mayor Thomas Lee, Adam Phillips, Sideck, and Fr. James Harding.

This c. 1940s photograph shows the teenage Al Ranger, an outstanding athlete at North Plainfield High School in football, wrestling, and track. South Plainfield had no high school until 1957. In college, Ranger wrestled and played football at East Stroudsburg University. Coach Ranger retired from the district school system in 1983 with a record of 700 wins, 100 losses, and 10 ties. He passed away in 1997.

Members of the 1960 South Plainfield High School basketball team reunite at a UNICO presentation of the Man of the Year award to coach Anthony "Tony the Tiger" Cotoia. From left to right are Paul Phillips, Paul Thievon, Coach Cotoia, Paul Sikanowicz, Ronald Kubowski, James Cirafisi, and James Kahora. This team was the first Plainfield area team to finish the regular season undefeated, with a 20-0 record.

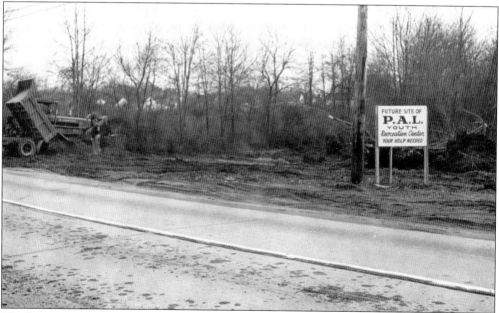

The future site of the Police Athletic League building on Maple Avenue looks a bit desolate in this photograph. It was close to the site of the former Holly Pond, which had been an important recreation location for the residents of South Plainfield and surrounding communities in the early 20th century.

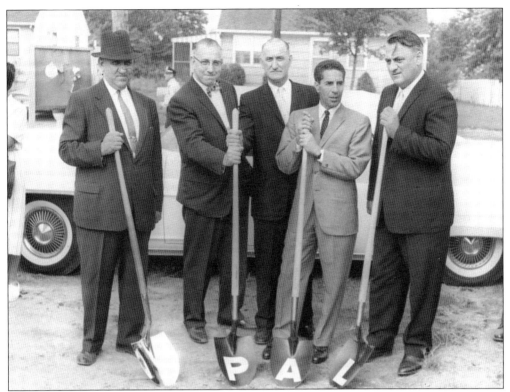

Pictured during ground breaking for the PAL are, from left to right, Chief Andrew Phillips, Mayor Robert Baldwin, unidentified, Yankees shortstop Phil Rizzuto, and unidentified. Phillips was the driving force behind the fundraising and construction of the building, which has provided generations of children with a place to play and work out. Having Rizzuto, then a popular announcer and media personality, present at the opening was a major event.

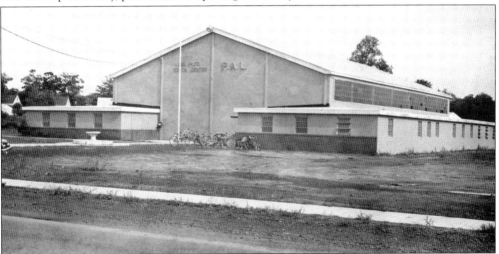

This photograph shows the newly completed PAL in 1962, before the grass had a chance to grow. South Plainfield has had an active recreation department since at least the 1940s. Residents took great interest in the department, and over 2,000 young people registered for recreation activities in 1965. Activities included soccer, basketball, bowling, softball, baseball, and twirling.

This is a c. 1970 action shot at the South Plainfield Community Pool. As early as 1959, planning was underway for a community pool. Initially conceived as a swim club, the site of the former Holly Lake Park was seen as a good site. Other sites were also considered, including a tract behind the municipal building. The pool finally opened in 1965.

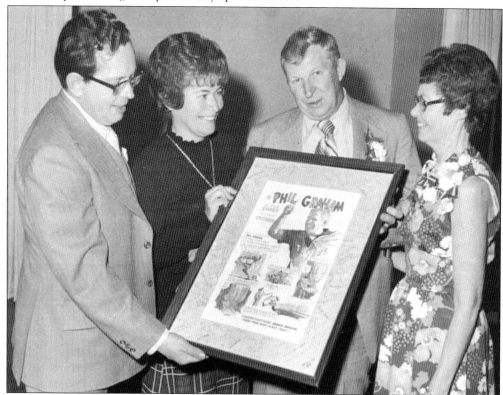

Coach Phil Graham (second from right), South Plainfield's legendary football coach, led the Tigers to a string of wins in the 1960s and 1970s. During his 12 seasons as coach, he amassed a 61-42-5 record, including an undefeated season in 1965. He also served as athletic director at Wardlaw-Hartridge School.

BIBLIOGRAPHY

Bicentennial History of the Borough of South Plainfield, A. Dunellen, NJ: Dunellen Litho Press, 1976.

Fifteenth Anniversary of Our Lady of Czestochowa Roman Catholic Church, South Plainfield, New Jersey, 1943–1958. South Plainfield, NJ: Our Lady of Czestochowa, 1958.

Raber Associates. *Historic American Engineering Record Documentation of Spicer Manufacturing Corporation, South Plainfield Works, South Plainfield, New Jersey, HAER No. NJ-144.* Prepared for Malcolm Pirnie Inc., 2011.

Randolph, Larry. *Looking Back at South Plainfield.* South Plainfield Historical Society, 2005.

Raser, Ed. "Samptown Baptist Churchyard, South Plainfield Borough." *The Genealogical Magazine of New Jersey* (90): 71–86.

Sacred Heart Church, South Plainfield, New Jersey. South Hackensack, NJ: Custombook Inc., 1965.

"Silver Anniversary." South Plainfield, NJ: St. Mary's Ukrainian Orthodox Church, 1959.

Veit, Richard F. Images of America: *South Plainfield.* Charleston, SC: Arcadia Publishing, 2002.

"Wesley United Methodist Church, 1896–1996." South Plainfield, NJ: Wesley United Methodist Church, 1996.

Discover Thousands of Local History Books Featuring Millions of Vintage Images

Arcadia Publishing, the leading local history publisher in the United States, is committed to making history accessible and meaningful through publishing books that celebrate and preserve the heritage of America's people and places.

Find more books like this at
www.arcadiapublishing.com

Search for your hometown history, your old stomping grounds, and even your favorite sports team.

Consistent with our mission to preserve history on a local level, this book was printed in South Carolina on American-made paper and manufactured entirely in the United States. Products carrying the accredited Forest Stewardship Council (FSC) label are printed on 100 percent FSC-certified paper.